Photographing
Animals & Pets

ROTOVISION
PRO-PHOTO SERIES

Photographing
Animals & Pets

JONATHAN HILTON

A RotoVision Book

Published and distributed by RotoVision SA
Rue du Bugnon 7
CH-1299 Crans-Près-Céligny
Switzerland

RotoVision SA, Sales and Production Office
Sheridan House, 112/116A Western Road
Hove, East Sussex BN3 1DD UK
Tel: + 44-1273-7272-68
Fax: + 44-1273-7272-69

Distributed to the trade in the United States:
Watson-Guptill Publications
1515 Broadway
New York, NY 10036

ISBN 2-88046-350-5

This book was designed, edited and produced by
Hilton & Stanley
63 Greenham Road
London N10 1LN
UK

Design by David Stanley
Illustrations by Brian Manning
Picture research by Anne-Marie Ehrlich

DTP in Great Britain by
Hilton & Stanley

Production and separation
by ProVision Pte. Ltd., Singapore.
Tel: + 65-334-7720
Fax: + 65-334-7721

Photographic credits
Front cover: Ulrich Wiede
Page 1: Paddy Cutts
Pages 2–3: Bert Wiklund
Page 160: Bert Wiklund
Back cover: Bert Wiklund

Contents

1

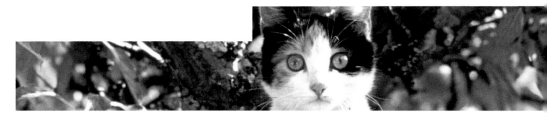

Household Pets

2

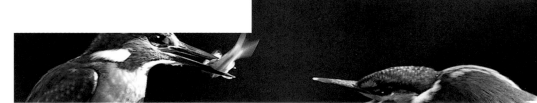

Local Wildlife

3

Farm and Working Animals

4
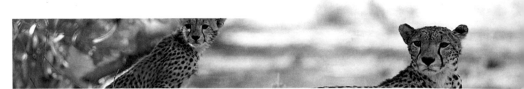

Safari and Game Parks

5

Portfolio

Introduction

As we all know, the old adage that warns against working with children or animals came about in the context of acting and the stage, but it has a special resonance with many photographers as well – at least the part of it that concerns working with animals. It is the sheer unpredictability of animal behaviour and their reactions that can be such a source of frustration – but it is this same unpredictability that can be so rewarding.

DOMESTIC ANIMALS

Photographers who specialize in taking pictures of domestic animals – mainly cats and dogs, but also small mammals, reptiles and fish – often have a special affinity for their subjects. Some, indeed, come from the ranks of full- and part-time animal commercial breeders and owners who, frustrated by not being able to commission competent animal photography, start taking pictures of their own animals, developing and refining their skills over a period of time into a parallel and profitable profession.

The market for photographs of domestic animals of all types is truly vast. Professional breeders have a constant need for pictures of their animals for sale, publicity or show purposes, but animal photographs are used in many other contexts: in the advertising of everything from pet food,

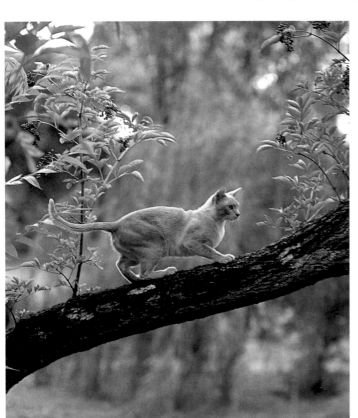

This picture of a Burmese lilac demonstrates that a well-conceived composition is more important to good photography than exotic subject matter.

PHOTOGRAPHER:
Paddy Cutts
CAMERA:
35mm
LENS:
135mm
FILM:
ISO 50
EXPOSURE:
$\frac{1}{25}$ second at f11
LIGHTING:
Daylight only

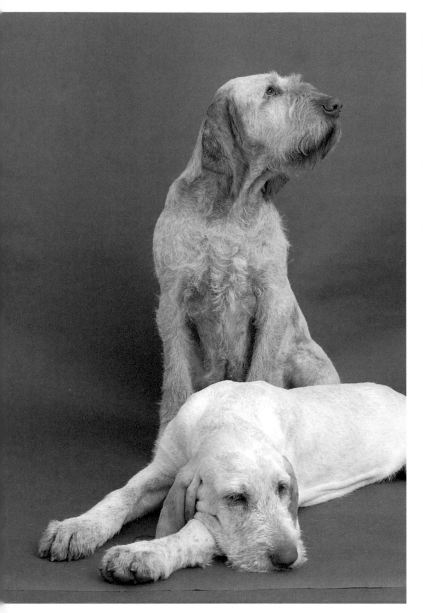

Working in the controlled environment of a studio solves lighting problems, but you still have to wait for your subjects to adopt the perfect pose and then react quickly.

PHOTOGRAPHER:
Paddy Cutts
CAMERA:
35mm
LENS:
80mm
FILM:
ISO 50
EXPOSURE:
⅟₆₀ second at f11
LIGHTING:
Studio flash x 2

two to three lights to give a good range of subject and background effects, a softbox or some other type of diffusing material, a snoot or barndoors are all you need. Patience, however, is required in large measure, as is the ability to coax from your subjects a good performance in front of the camera – qualities that come with experience and a generally confident attitude around animals. If you are at all nervous or unsure of yourself handling animals this will be instantly transmitted to them. Not only does this make the photo session harder to control, and photographic results less certain, animals handled in a timid fashion are more likely to become unruly, leading to the possibility of them injuring themselves or you. Also, bear in mind that for cats and other small animals you will need a litter tray somewhere in the studio, while dogs and other large animals will need easy access to a secure outside area where they can relieve themselves.

WILD ANIMALS

As the natural landscape rapidly disappears under the onslaught of encroaching tarmac and concrete, or is progressively lost to the plough, photographing wild animals becomes increasingly poignant and important.

cars, clothes and paint, to household insurance, leisure products and furniture; in company product leaflets; calendars; greetings cards; book and magazine illustration; poster campaigns; and promotional material too numerous to list here.

Unless you are working outdoors on location or at the client's premises, an averagely equipped studio (or spare room in your home) is all you need. Lighting requirements for studio shots of animals don't differ markedly from those needed for taking pictures of people –

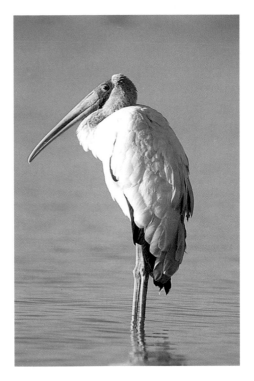

▲

A long telephoto lens and a well-camouflaged hiding place are essential requirements for taking pictures of wild animals, such as this Kenyan yellow-billed stork.

PHOTOGRAPHER:
Roy Glen
CAMERA:
35mm
LENS:
400mm (plus x1.4 tele converter)
FILM:
ISO 50
EXPOSURE:
$\frac{1}{125}$ second at f11
LIGHTING:
Daylight only

Fortunately, you often don't have to go far to find suitable subjects. Urban backyards can be a haven for many different species of birds as well as frogs, toads, foxes, hedgehogs, badgers and other refugees from the countryside. Species that are active by day are obviously more accessible than nocturnal creatures, and offerings of suitable food or water will often coax them into range of your camera. Animals are often creatures of habit, using the same routes, perching on the same branches, visiting the same feeding spots at much

▲

There is always an element of being in the right place at the right time when it comes to wildlife photography, as you can see in this touching family portrait.

PHOTOGRAPHER:
Roy Glen
CAMERA:
35mm
LENS:
300mm
FILM:
ISO 100
EXPOSURE:
$\frac{1}{125}$ second at f8
LIGHTING:
Daylight only

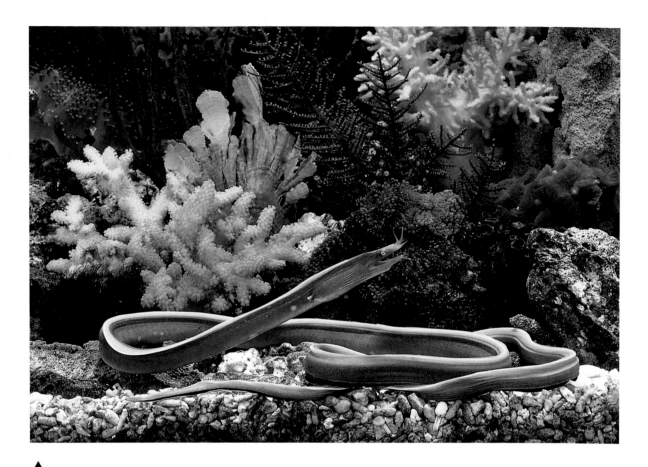

the same time day after day. Get to know the habits of your chosen subjects and you should be able to find the ideal shooting position well in advance of their arrival.

With the advent of game and safari parks, even the most exotic of animals can be recorded by the averagely well-equipped photographer. In these types of environment you will almost certainly be under the supervision of trained and experienced rangers whose job it is to get you as close to the animals as safety (theirs as well as yours) allows. Even so, you will almost certainly need lenses covering the wide-angle (to show

animals and their setting) to long tele-photo (for close-ups of shy or dangerous animals) range. Zoom lenses in the 28–210mm range (for 35mm cameras) offer you a good range of focal length settings and are easy to hand hold, even at reasonably slow shutter speeds, if you take just a little care. However, more powerful telephotos, in the 400–600mm range, may also be needed.

If you are not familiar with powerful telephoto lenses, take a test roll of film and study the results before setting off on your trip – these lenses are heavy and they can initially be awkward to use and difficult to focus.

Equipment and Accessories

THE SCOPE OF THIS BOOK encompasses two very different photographic approaches and types of technique. First, for studio-based photography of household pets and, to a degree, the more informal photography of pets by their owners at home, equipment requirements are similar to those of any other studio photographer, and medium format equipment is often the preferred choice. Second, for wildlife photography, of local wildlife as well as animals in safari and wildlife parks, the reduced weight, speed of operation and range of lenses available all combine to make 35mm cameras an attractive option.

Medium format cameras produce a larger negative (or positive slide image) than 35mm cameras. Generally speaking, the larger the original film image, the better the quality of the resulting print or projected slide, since it requires less enlargement. The often relatively slow pace of an animal portrait session also seems to favour the use of the larger format, since it tends to encourage a more considered approach to each shot. However, good-quality 35mm SLR cameras and lenses are capable of producing superb results, and they come into their own when hand-held shooting is necessary, for 'grabbed', opportunistic shots, or when the action is unpredictable and the photographer needs to respond very quickly to the changing situation.

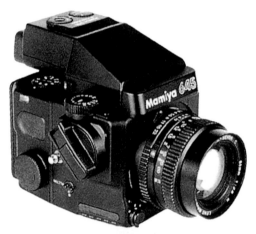

This is the smallest of the medium format cameras available, producing rectangular negatives or slides measuring 6cm by 4.5cm.

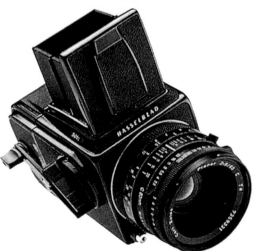

This is probably the best known of all the different medium format cameras, producing square-shaped negatives or slides measuring 6cm by 6cm.

Medium format cameras

This camera format, of which there are many variations, is based on 120 (for colour or black and white) or 220 (mainly black and white) rollfilm. Colour film has a thicker emulsion than black and white, and so 220 colour film is not generally available because it cannot physically be accommodated in the film chamber of the camera.

The three most popular sizes of medium format cameras are 6 x 4.5cm, 6 x 6cm and 6 x 7cm models. The

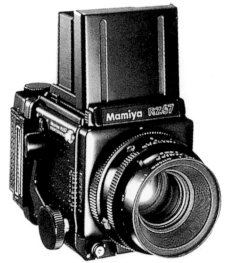

◀ This is the largest of the popular medium format cameras, producing rectangular negatives or slides measuring 6cm by 7cm. (A 6 x 9cm format is also available but is not commonly used.)

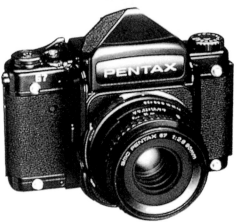

◀ This type of 6 x 7cm medium format camera looks like a scaled-up 35mm camera, and many photographers find the layout of its controls easier to use than the more box-like models.

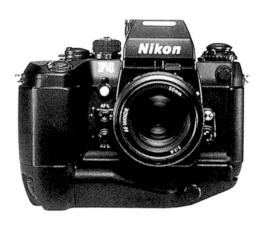

◀ This top-quality professional 35mm camera, here fitted with a motor drive, features a die-cast body; a choice of metering systems, different viewing screens and finders; exposure lock and compensation; and a choice of aperture- or shutter-priority, fully automatic or manual exposure.

number of exposure per roll of film you can typically expect from these three cameras are:

Camera type	120 rollfilm	220 rollfilm
6 x 4.5cm	15	30
6 x 6cm	12	24
6 x 7cm	10	20

The advantage most photographers see in using medium format cameras is that the large negative size – in relation to the 35mm format – produces excellent-quality prints, especially when big enlargements are called for, and that this fact alone outweighs any other considerations. The major disadvantages with medium format cameras are that, again in relation to the 35mm format, they are heavy and can be awkward to use, they are not highly automated (although this can often be a distinct advantage in certain situations), they (and their lenses) are expensive to buy and you get fewer exposures per roll of film.

35mm single lens reflex cameras (SLRs)

Over the last few years, the standard of the best-quality lenses produced for the 35mm SLR has improved to the degree that for average-sized enlargements – of, say, about 20 x 25cm (8 x 10in) – results are superb.

The 35mm format is the best supported of all the formats, due largely to its popularity with amateur photographers. There are at least six major 35mm manufacturers, each making an extensive range of camera bodies, lenses, dedicated flash units and specialized as well as more general accessories. Cameras within each range include fully manual and fully automatic models. Lenses and accessories made by

independent companies are also available. Compared with medium format cameras, 35mm SLRs are light-weight, easy to use, generally feature a high degree of automation and are extremely flexible working tools. For big-sized enlargements, however, medium format camera often have an edge in terms of picture quality.

All 35mm SLRs use the same size of film cassette – either 24 or 36 frames – in colour or black and white, positive or negative. Again, because of this format's popularity, the range of films available is more extensive than for any other type of camera.

Lenses

When it comes to buying lenses you should not compromise on quality. No matter how good the camera body is, a poor-quality lens will take a poor-quality picture, and this will become all too apparent when enlargements are made. Always buy the very best you can afford.

One factor that adds to the cost of a lens is the widest maximum aperture it offers. Every time you change the aperture to the next smallest number – from f5.6 to f4, for example – you double the amount of light passing through the lens, which means you can shoot in progressively lower light levels without having to resort to flash. At very wide apertures, however, the lens needs a high degree of optical precision in order to produce images with minimal distortion, especially toward the edges of the frame. Thus, lenses offering an aperture of, for example, 1.4 cost much more than lenses with a maximum aperture of only f2.8.

For studio work, the type of lenses you will probably most often use will be in range between moderate wide-angle (say, 28mm for 35mm cameras) to moderate telephoto (about 200mm for

600mm telephoto lens

500mm mirror lens

35mm cameras). However, for shots of animals running wild, when you will not be able to approach them without endangering yourself or causing your subjects alarm, then more extreme tele-photo lenses will often be needed. For this type of work, optics of 400mm or 500mm are quite common, and these can be used in conjunction with tele-converters (small lenses that fit between the camera body and the prime lens) if necessary, which further enhance subject magnification. The disadvantages of using these devices is that less expen-sive types can degrade image quality but they all reduce the speed of the prime lens to some degree, resulting in a darker viewfinder image and more difficult focusing in dim light. Teleconverters can, however, double or even triple a lens's magnification for only a minimal increase in weight.

Weight is a major consideration when you are thinking of using of long lenses. At extreme magnification, even the slightest camera movement will result in unacceptably blurred pictures, and so very fast shutter speeds have to be used unless the camera is mounted on a tripod, monopod, or some other support. Fast shutter speeds require wide apertures to compensate for exposure, and wide apertures are not often found on extreme telephotos.

As a weight-saving measure, you could consider using mirror, or cata-dioptric, lenses (see page 13). This type of optic substitutes mirrors instead of the more usual glass elements found inside the lens barrel. This measure makes the lens not only lighter, but also more compact, since the light from the subject is bounced up and down the barrel, mimicking the distance light would have to travel inside a much longer conventional lens. However,

there always seems to be a trade-off, and the saving you make in weight is somewhat offset by the fact that mirror lenses are very slow, commonly with a maximum aperture of only f8.

As an alternative to carrying about a range of fixed focal length prime lenses, you could consider using a combination of different zoom lenses. For example, you could have a 28–70mm zoom, another covering the range 70–210mm and, for distant wildlife subjects a zoom in the range 200–500mm. In this way you have, in just three lenses, the extremes you are likely to want to use, plus all the intermediate settings you could possibly need to 'fine-tune' subject framing and composition. Bear in mind that the weight of a zoom lens in the range 200–500mm would always require the use of a sturdy camera support unless it has a built-in image stabilizer to smooth out the blurriness caused by camera movement.

There is less choice of focal lengths for medium format cameras. They are also larger, heavier and more expensive to buy, but the same lens categories apply – in other words, wide-angle, standard and moderate telephoto. There is also a limited range of medium format zoom lenses to choose from.

Accessory flash

The most convenient artificial light source for small-scale studio work or, on occasion, when you are working on location is undoubtedly an accessory flashgun. Different flash units produce a wide range of light outputs, so make sure that you have with you the one that is most suitable for the type of area you need to illuminate.

Tilt-and-swivel flash heads give you the option of bouncing light off any

convenient wall or ceiling. In this way, your subject will be illuminated by reflected light, which produces a kinder, more flattering effect. You need to bear in mind, however, that some of the power of the flash will inevitably be absorbed and dissipated by being bounced off an intervening surface before reaching the subject.

The spread of light leaving the flash head is not the same for all flash units. Most are suitable for the angle of view of moderate wide-angle, normal and moderate telephoto lenses. However, if you are using a lens with a more extreme focal length, you may find its light coverage inadequate. Some flash units can be adjusted to suit the angle of view of a range of focal lengths, or adaptors can be fitted to alter the spread of light leaving the flash tube.

Long-life lighting One of the problems of using accessory flash is the number of times the flash will fire before the batteries are exhausted. There is also the problem of recycling time – the number

of second (or minutes) it takes for the batteries to build up sufficient power in order to fire once more. With ordinary batteries, after as few as 30 firings recycling time may be so long that you need to change batteries (the fresher the batteries, the faster the recycling time). This is not only expensive, it is also time consuming. The solution to these problems is to use a battery pack. With some types of pack, when it is fully charged you can expect as many as 4,500 firings and a flash recycling time as low as ¼ second – which is fast enough to use with a camera and auto-winder. These figures do, of course, assume optimum conditions, such as photographing a nearby subject, with plenty of reflective surfaces nearby to return the light and with the flashgun set to automatic.

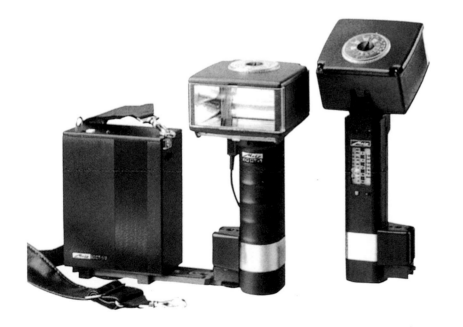

◀
'Hammer-head' style accessory flashguns are capable of pro-ducing high light levels and so are often used with heavy-duty battery packs. Always choose a model with a tilt-and-swivel head facility for a variety of lighting effects.

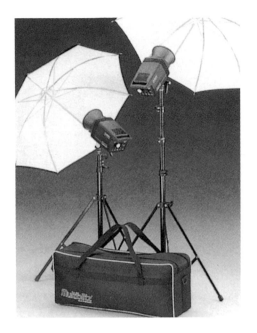
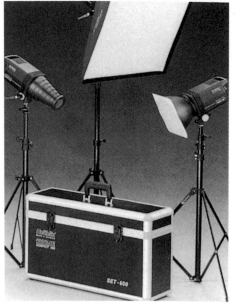

▲ ▶

These modern studio flash units have been designed with location work in mind. Both set-ups, comprising lighting heads, snoot, softbox, umbrellas and stands, pack away into the carrying bag or case illustrated.

Studio flash

For the studio-based photographer, the most widely used light source is studio flash. Working either directly from the mains or via a high-voltage mains power pack, recycling time is virtually instantaneous and there is no upper limit on the number of flashes.

A range of different lighting heads, filters and attachments can be used to create virtually any lighting style or effect, and the colour temperature of the flash output matches that of daylight, so the two can be mixed in the same shot without any colour cast problems.

When more than one light is in use, as long as one of them is linked to the camera's shutter, synchronization cables can be eliminated by using the slave unit found on most modern lighting heads. Another advantage of flash is that it produces virtually no heat, which can be

a significant problem when using studio tungsten lighting. To overcome the problem of predicting precisely where subject shadows and highlights will occur, which cannot be seen normally because the burst of light from the flash is so brief, each flash head should be fitted with a 'modelling light'. The output from these lights is low and won't affect exposure, but it is sufficient for you to see the overall effect with a good degree of accuracy.

Working from hides

When you are photographing wild animals – perhaps garden wildlife such as birds, foxes, or badgers, but more likely animals in safari parks, animal sanctuaries, or wildlife parks – your chances of capturing natural animal behaviour will be dramatically improved if you shoot from a hide of some description so that your subjects are unaware of your presence.

Although not an obvious hide, many animals don't associate cars with people and will approach a vehicle quite

fearlessly while you shoot from inside, either through the glass if the subject is potentially dangerous, or with the window rolled down. To prevent vibrations from the car frame spoiling your photographs, turn the engine off before starting to shoot.

A car makes a fine makeshift hide for opportunistic photography, but often with wildlife subjects you will need to set up a more permanent hide and wait patiently for your subject to come within range of your lens. If a hide is going to be used for prolonged periods, then it needs to be of a reasonable size. You will not be able to stay still and quiet for very long if the hide does not at least allow you enough space to stand and stretch every now and again.

Any new structure in an animal's territory will arouse suspicion and may be avoided for days on end until the animal is certain that it does not represent a threat of any type. You may, therefore, need to set it up and then leave it unattended until its presence has been accepted by local wildlife. When you come to install yourself and equipment in the hide, make sure the animals you want to photograph do not catch sight of you or all your patient waiting will be undone.

▶

If you are going to make repeated use of a hide, then it pays to build it well. Use sturdy, well-preserved wooden structural timber and leave sufficient space inside for you to be able to move about and stretch your aching muscles. Use natural cover, such as that from a nearby tree, to help your hide blend in.

▲

If bird photography is your passion, then a tree hide, along the lines of the one shown here, will be perfect. Build a supporting frame of timber over substantial tree branches for the flooring but then save weight by making the sides of the hide out of lightweight canvas.

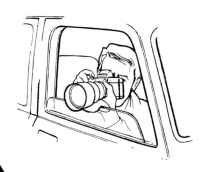

▲

With the engine off (to stop vibration), adjust the height of the window until the lens is at the right height. Use a bean bag, or similar, to cushion the lens barrel.

▶

A few square yards of heavy-duty canvas, four tent pegs and guy ropes is all you need for an easily transportable, quickly erected hide suitable for all manner of animal photography.

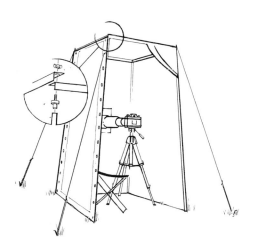

1

HOUSEHOLD PETS

Detailed close-ups

IN ORDER TO OBTAIN A CLOSE-UP PHOTOGRAPH of just a part of an animal the size of a domestic cat, you have two basic choices. First, you can move your camera and, if you are shooting indoors with insufficient natural illumination, your lighting set-up close to the animal and shoot with a standard (50mm or 55mm on a 35mm camera) or a moderate wide-angle lens (35mm or 28mm). Second, you can decide to shoot from further back and use a telephoto lens to isolate just the detail you want to concentrate the viewer's attention on. Just how far back you need to stand depends on the focal length of your available lenses and, to a degree, on the size of your subject as well.

The first option of moving in close to the subject tends to be best when you are photographing your own animal (or one that is very familiar with you), or a client's animal that has a particularly calm disposition. Until you have won its trust, crowding in a nervy or unfamiliar animal with not only your own presence but also that of a camera and lighting outfit is pretty well guaranteed to produce a fractious photo session, a tense client and, probably, an unsatisfactory set of pictures at the end of the day. In most circumstances, you will have a more productive time if you rely on the magnifying effect of a long lens (fitted with a x2 or x3 teleconverter, if necessary) and then stand well back to give the animal plenty of space to relax in. A 135mm lens, for example, fitted with a x2 converter will produce an effective focal length of 270mm, and x3 will give you about 400mm.

Bear in mind that adaptors will result in some loss of lens speed, but this will be allowed for by the TTL (through-the-lens) metering system if the adaptors have the appropriate pin connections to link up with your camera's metering system.

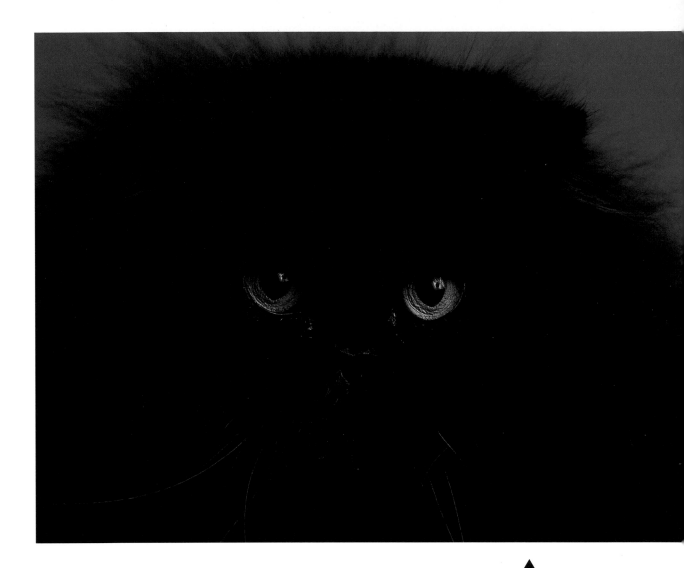

POTENTIAL EXPOSURE PROBLEMS

When you are judging exposure for an animal such as cat that has black or very dark-coloured fur, it is important that your exposure reading excludes any light-coloured or light-toned surfaces that may be in the immediate vicinity. With through-the-lens metering, other that spot-metering cameras, make sure that the lens is close enough to the animal to exclude any irrelevant colours or tones – likewise with the sensor of a hand-held light or flash meter. Once you have taken a reading, lock this into the camera's circuitry and then move back to re-compose the picture before shooting.

PHOTOGRAPHER:
Paddy Cutts
CAMERA:
6 x 4.5cm
LENS:
180mm
FILM:
ISO 50
EXPOSURE:
$\frac{1}{125}$ second at f11
LIGHTING:
Daylight and direct studio flash

Here the photographer used a moderate telephoto lens to show only the cat's face and those incredibly piercing yellow eyes. Window light was supplemented by direct studio flash, slightly angled to delineate the cat's whiskers against its dark fur.

Coaxing a performance

▼

This is a formal portrait of a young brown-tipped Burmilla looking just a little apprehensive about its first visit to the photographer's studio.

WHEN WORKING IN THE STUDIO with a client's pet, take the opportunity to produce as wide and varied a selection of photographs as possible. Many owners of pedigree and show cats and dogs require quite formal portraits, showing the animal standing or sitting in order to display the best features of the particular breed.

However, as well as being 'professional' animals, many are also much-loved family pets, so also take some pictures showing the animals in a more relaxed and playful mode. Younger animals, of course, are often far easier to coax in this regard, but mature, older animals – ones that have perhaps visited the photographer's studio many times in the past or are used to being on public display at animal shows – may be more relaxed about the whole affair and so will be more inclined to cooperate if they are offered the correct incentives.

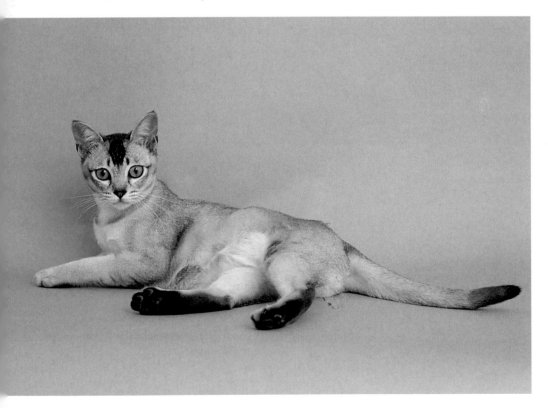

PHOTOGRAPHER:
Paddy Cutts
CAMERA:
6 x 4.5cm
LENS:
120mm
FILM:
ISO 50
EXPOSURE:
⅟₆₀ second at f8
LIGHTING:
Diffused studio flash

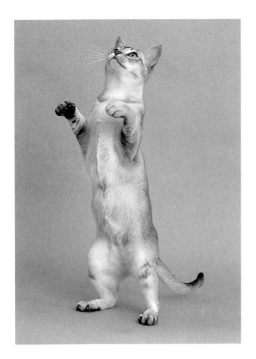

▲

Far more alert and playful now, for this shot the photographer asked the cat's owner to encourage it up on to its back legs.

PHOTOGRAPHER:
Paddy Cutts
CAMERA:
6 x 4.5cm
LENS:
120mm
FILM:
ISO 50
EXPOSURE:
⅟₆₀ second at f8
LIGHTING:
Diffused studio flash

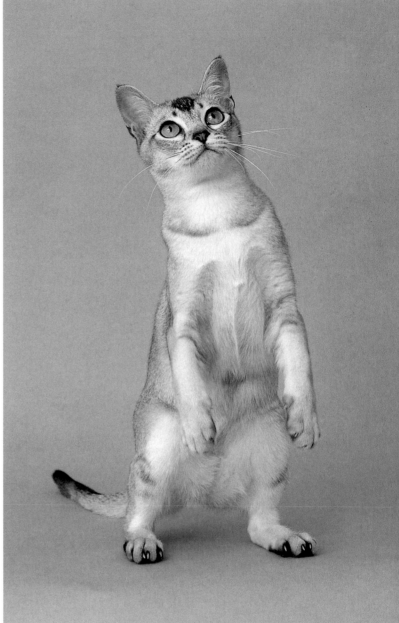

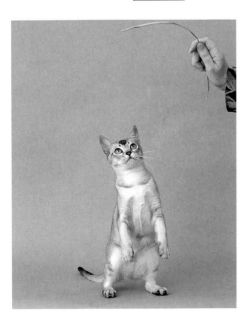

▲

With the camera mounted on a tripod, prefocused and with the exposure set, you can move about quite freely and use a long cable release to trigger the shutter at the right moment. In the smaller version (left) you can see the photographer's hand holding a piece of wire well above the cat's head. At the printing stage, all you need do is enlarge the negative (or positive) to crop out the hand and show the animal alone (above).

PHOTOGRAPHER:
Paddy Cutts
CAMERA:
6 x 4.5cm
LENS:
120mm
FILM:
ISO 50
EXPOSURE:
⅟₆₀ second at f8
LIGHTING:
Diffused studio flash

Making the most of the setting

ONE OF THE PRINCIPAL ADVANTAGES of photographing household pets outside of the studio environment is that you then have the opportunity to show your subjects in varied and far more revealing and interesting settings. No matter how much effort you put into a studio set, it will always be an artificial and a rather sterile backdrop to your subject. However, once you move outside, rather than producing a straight animal portrait, you will have the wider concerns and complexities of composition and the vagaries of natural lighting to consider.

If the task you have undertaken is to photograph your pet, or a client's animal if you are a professional, then don't fall into the trap of making the setting the subject of the photograph, while somewhere within that setting there happens to be an animal. Keep a clear notion at all times that the cat, dog, or whatever animal it happens to be, needs to be the main focus of the viewer's attention and use such factors as depth of field, lens focal length, exposure and camera viewpoint to manipulate the emphasis of the shot and bring about this objective.

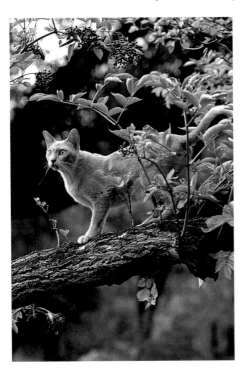

◄

Cats and trees are a natural combination. The advantages of photographing from ground level looking up at your subject is that you can eliminate much extraneous and distracting subject matter often found in town gardens – fences, walls, garden furniture, house windows and so on. With the cat up a tree, you can frame it against an attractive background of foliage of sky.

PHOTOGRAPHER:
Paddy Cutts
CAMERA:
35mm
LENS:
135mm
FILM:
ISO 100
EXPOSURE:
¹⁄₂₅ second at f5.6
LIGHTING:
Daylight only

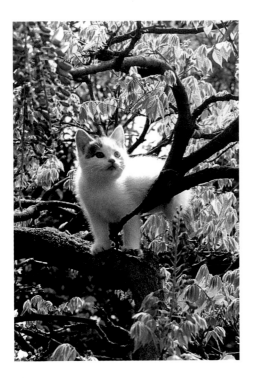

▲

A quick change of camera position was required to take this shot in order to show the kitten unobscured by leaves, branches or wisteria flowers.

PHOTOGRAPHER:
Paddy Cutts
CAMERA:
35mm
LENS:
90mm
FILM:
ISO 100
EXPOSURE:
1/125 second at f11
LIGHTING:
Daylight only

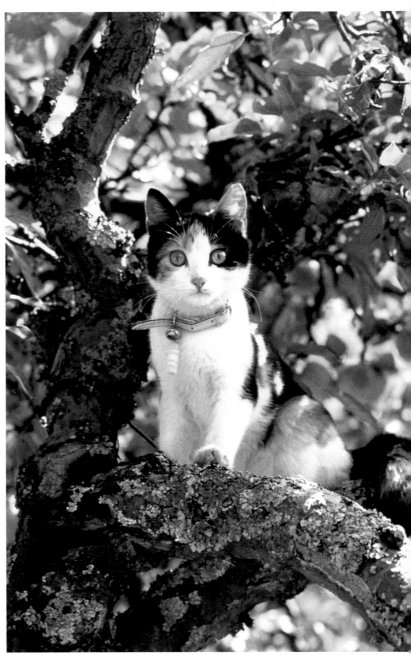

▲

Although predominantly backlit, the tent-like foliage surrounding this cat has confined the dappled light and produced a consistent exposure right across the frame.

PHOTOGRAPHER:
Paddy Cutts
CAMERA:
35mm
LENS:
90mm
FILM:
ISO 100
EXPOSURE:
1/60 second at f8
LIGHTING:
Daylight only

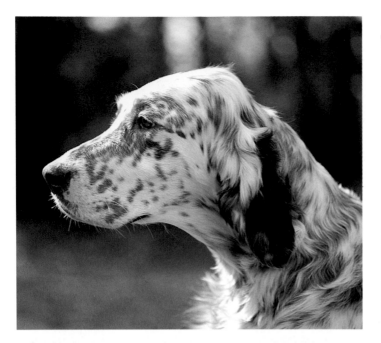

The idea behind this shot was to show this dog – an English setter – in the type of setting the breed has been designed to work in. However, the angle of view of the lens is a bit too narrow and the background so out of focus that little extra information is imparted to the viewer.

PHOTOGRAPHER:
Paddy Cutts
CAMERA:
6 x 4.5cm
LENS:
180mm
FILM:
ISO 100
EXPOSURE:
½₅₀ second at f5.6
LIGHTING:
Daylight only

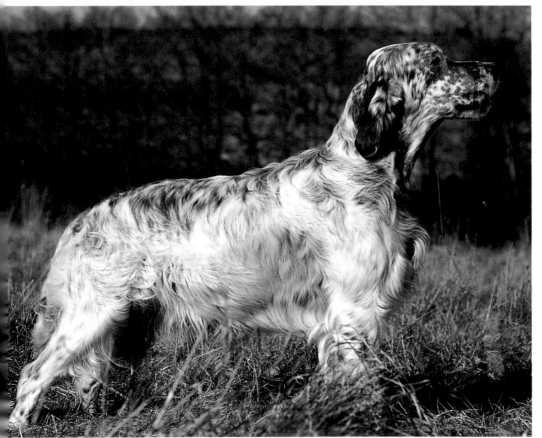

A broader view here opens up the landscape more than in the previous shot. The profile pose is a classic one, intended to show the coat, stance and lines of the animal. However, the camera angle is not showing the setting at its best.

PHOTOGRAPHER:
Paddy Cutts
CAMERA:
6 x 4.5cm
LENS:
80mm
FILM:
ISO 100
EXPOSURE:
½₂₅ second at f5.6
LIGHTING:
Daylight only

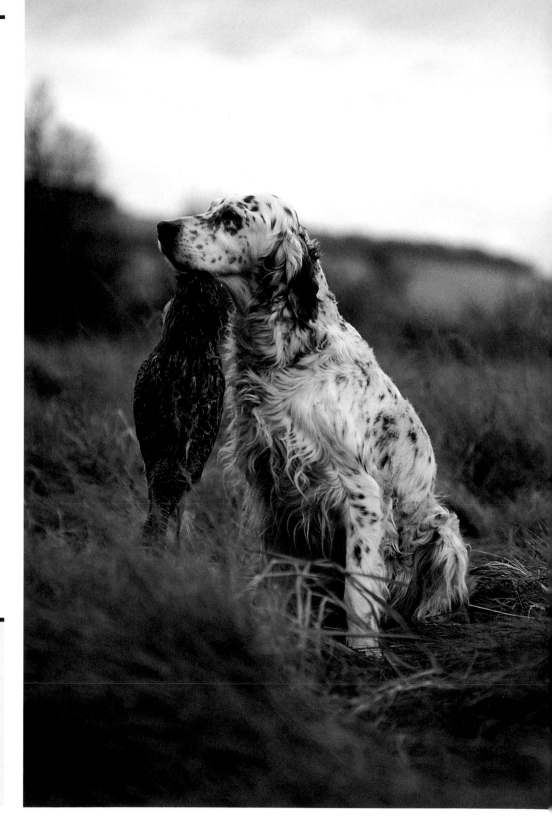

This is by far the best shot of this set of an English setter. The dog's pose, with a retrieved bird held gently in its mouth, is perfect, and the setting of grass, hills and sky gives us a real feeling for the type of country these dogs habitually work in.

PHOTOGRAPHER:
Paddy Cutts
CAMERA:
6 x 4.5cm
LENS:
80mm
FILM:
ISO 100
EXPOSURE:
¹⁄₆₀ second at f5.6
LIGHTING:
Daylight only

Selecting a background

BOTH FOR OUTDOOR SHOTS as well as for informal indoor photographs at home, or more formal studio animal portraits, you need to take careful note of the backdrop against which your subject will be seen. In the studio, the likelihood is that you will be showing the animal against some type of neutral-toned or coloured background paper. The object of a studio photo session is likely to be to produce a picture, or set of pictures, showing the subject without the distractions that are invariably inherent in any type of more natural, outdoor setting. However, the colour, tone and texture of the background should be chosen to show the animal to best advantage rather than to compete for attention. Too saturated a hue, for example, could overwhelm your subject, while a background colour or tone that is too similar to that of the subject could make it difficult to differentiate it from its surroundings. Ideally, you should aim to produce a degree of contrast between subject and background. In addition to helping to project the subject forward in the frame, utilizing contrast between the foreground and background elements of a photograph also makes for a visually more complex and exciting image.

◀ ▶

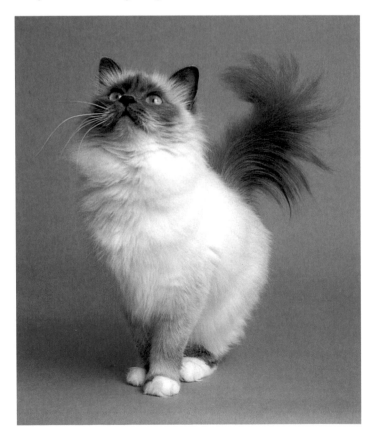

These two studies (a Birman blue and a Birman seal point) benefit from a background colour that both contrasts with their large areas of white fur while harmonizing with their distinctly blue eyes. If the cats' fur had been composed predominantly of the dark areas you can see, however, then the chosen colour of the background would have been totally inappropriate.

PHOTOGRAPHER:
Paddy Cutts
CAMERA:
35mm
LENS:
90mm
FILM:
ISO 50
EXPOSURE:
⅟₆₀ second at f16
LIGHTING:
Diffused studio flash

PHOTOGRAPHER:
Paddy Cutts
CAMERA:
6 x 4.5cm
LENS:
120mm
FILM:
ISO 50
EXPOSURE:
⅟₆₀ second at f11
LIGHTING:
**Studio flash fitted
with softbox**

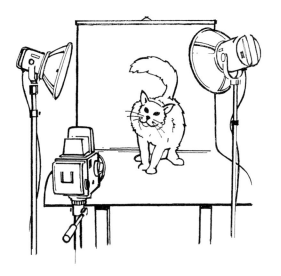

◄

**When working in
the studio with a
small animal such
as a cat, you either
have to work low
down at, or about,
the height of the
subject's eyes, or
raise the subject
up to a more com-
fortable shooting
height. In most
cases, it is easier
to position the
subject on a raised
platform covered
in background
paper. Make sure
that a skitty animal
cannot fall off the
edge of the set-up.**

There are both advantages and
disadvantages to working outdoors with
pets and animals. On the plus side, by
selecting the right type of setting you
can communicate more to the viewer
about the animal, its personality, habits
and functions than is often possible in a
studio environment.

But on the negative side, you do not
have the same control over such factors
as lighting as you would in the studio,
and you also run the risk of diminishing
the impact of the subject by allowing the
background to assume too dominant a
role. If the composition is handled with
care and sensitivity, however, location
work can be extremely rewarding.

▶ What better setting in which to show a pair of magnificent English setters than this – the type of country-side the breed would naturally work in when retrieving game? You can turn the discipline and obedience of work-ing dogs such as these to your advantage. If you are not used to handling dogs, ask their owners to position them where you specify – in this example, the owner had one sitting up and the other lying down at the photog-rapher's request. Even the angle of the sitting dog's head was contrived by the owner pointing and attracting the dog's attention. Although the setting was crucial to the shot, the photographer took care to use a wide lens aperture so that the back-ground was not too sharp and, therefore, intrusive.

PHOTOGRAPHER:
Paddy Cutts
CAMERA:
6 x 4.5cm
LENS:
90mm
FILM:
ISO 100
EXPOSURE:
$\frac{1}{250}$ second at f4
LIGHTING:
Daylight only

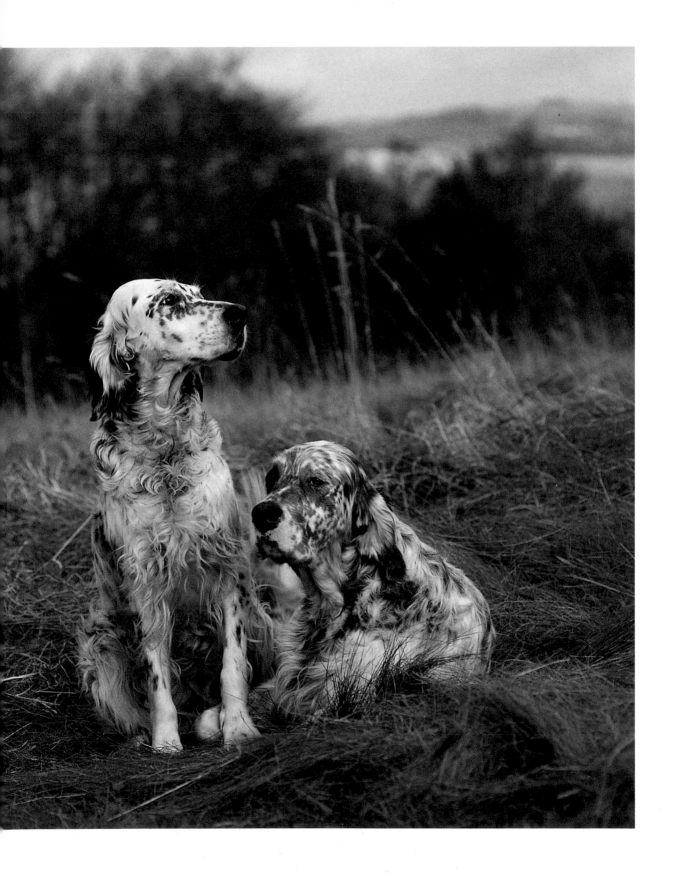

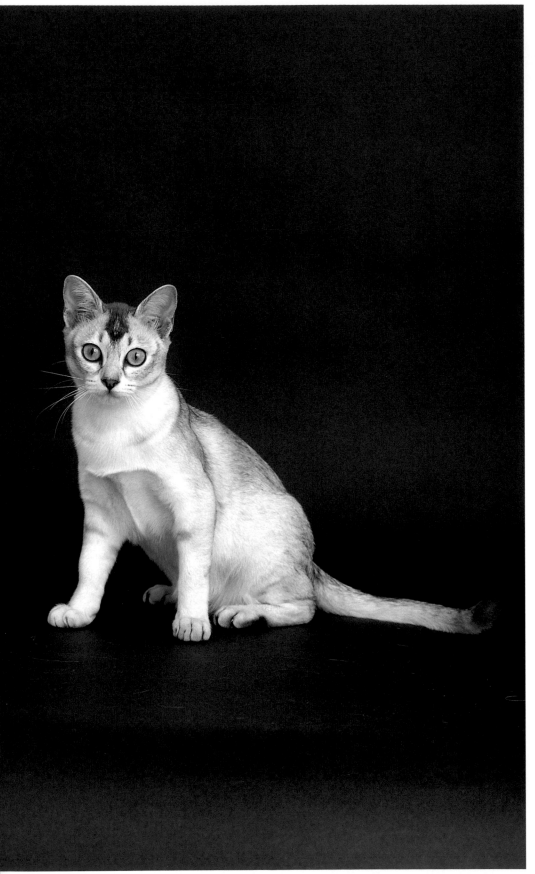

These two photographs illustrate just how effectively you can use contrast to give your work real impact. The colouring of the cats – a Burmilla and a family of Birmans – was the initial inspiration, and the photographer chose to position them in a set lined completely with dark, charcoal-grey background paper. Lighting was provided by studio flash, which was direct for the Burmilla and diffused with a softbox for the Birman and kittens.

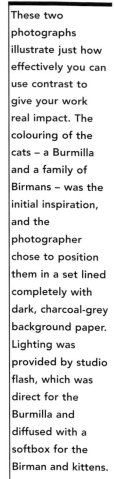

PHOTOGRAPHER:
Paddy Cutts
CAMERA:
6 x 4.5cm
LENS:
120mm
FILM:
ISO 50
EXPOSURE:
1/125 second at f16
LIGHTING:
Studio flash

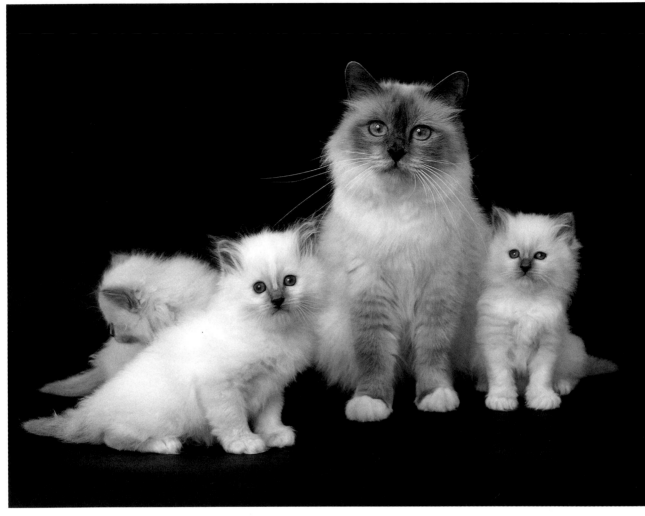

◀
The lighting set-up for the shots above and left was identical – a single flash unit immediately adjacent to the camera. However, for the single cat undiffused flash was used, while the softer, more-rounded forms of the long-haired Birmans were more suited to diffused lighting. The grey background paper was draped behind the cats and brought forward in a single piece to cover the table-top they were positioned on. For both shots the angle of the lighting unit was just above the cats, slightly looking down on them. This helped to prevent them casting any shadows on to the background.

PHOTOGRAPHER:
Paddy Cutts
CAMERA:
6 x 4.5cm
LENS:
120mm
FILM:
ISO 50
EXPOSURE:
⅟₆₀ second at f8
LIGHTING:
Studio flash fitted with softbox

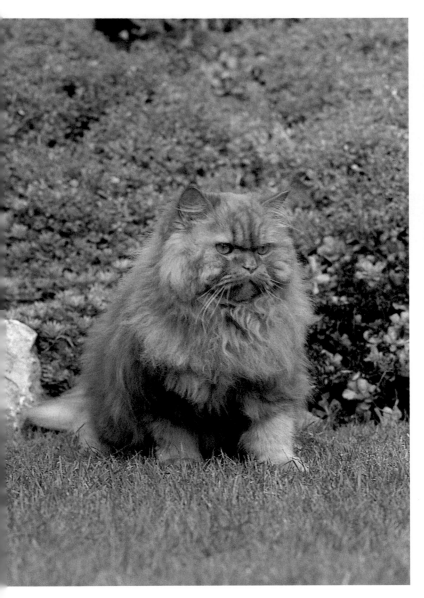

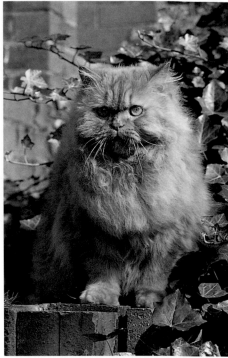

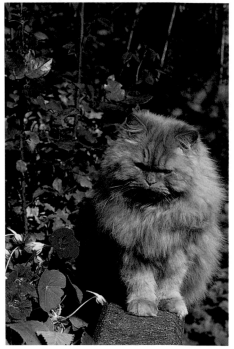

PHOTOGRAPHER:
Paddy Cutts
CAMERA:
35mm
LENS:
70–210mm zoom
FILM:
ISO 100
EXPOSURE:
**$\frac{1}{125}$ second at
between f4
and f11**
LIGHTING:
Daylight only

◀ ▶

These four pictures were all shot in the garden of the cat's home, with the photographer simply following the long-haired red around picking off shots as opportunities presented themselves. Although the pictures reflect the informal approach adopted by the photographer, you can also see how the various backgrounds impact on the subject. For all pictures, a 70–210mm zoom lens was used. This lens gives you lots of scope for fine-tuning composition by using different focal length settings to decide what to include in the picture area and what to omit. Also, the extreme telephoto end of the range lets you stand a good way back from the cat while the subject appears large in the viewfinder.

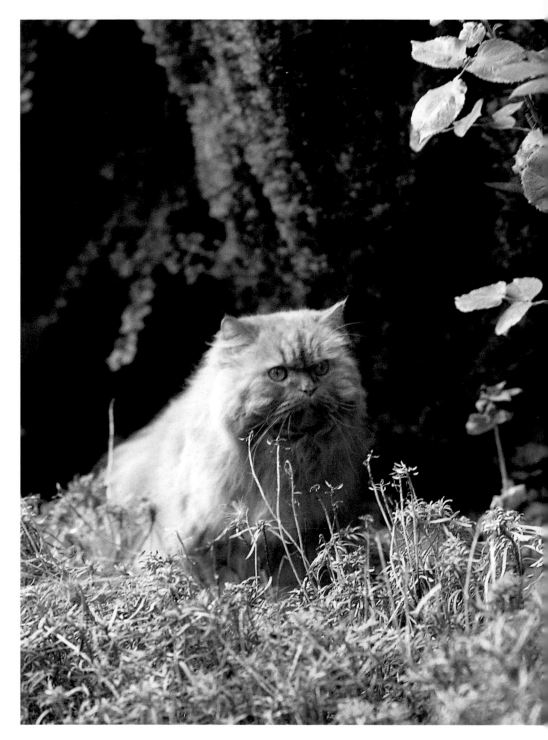

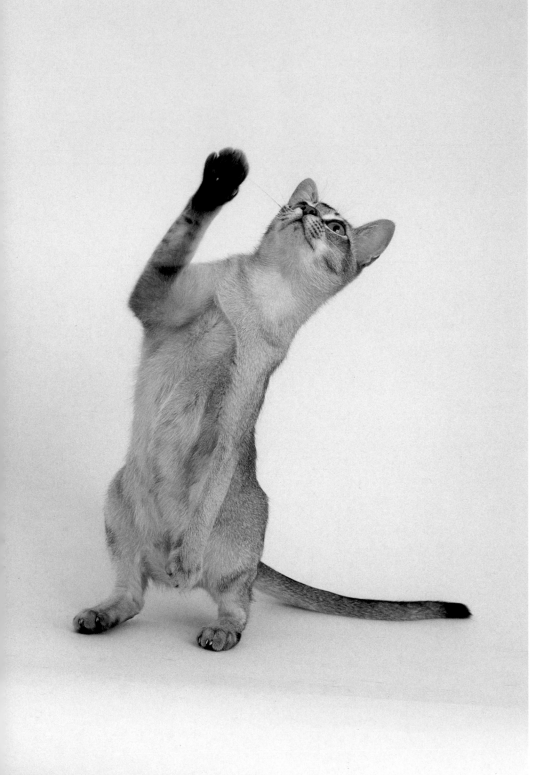

The colour of the background you select can be vitally important. In this cat portrait, the photographer has chosen a background paper that has almost the same colour and tonal value as the subject. Note how flat the picture looks as a result. Any sense of depth is missing since the cat and background both seem to be in the same image plane.

PHOTOGRAPHER:
Paddy Cutts
CAMERA:
6 x 4.5cm
LENS:
150mm
FILM:
ISO 50
EXPOSURE:
1/60 second at f16
LIGHTING:
Studio flash fitted with softbox

This is the same cat as pictured in the previous shot (left), but for this version the photographer has changed the colour of the background paper. The warm-toned brown/terracotta colour harmonizes well with the colouring of the cat, and now there is a clear distinction between the foreground and the background and, as a result, the subject seems to come forward in the frame to give a three-dimensional impression of depth and distance.

PHOTOGRAPHER:
Paddy Cutts
CAMERA:
6 x 4.5cm
LENS:
150mm
FILM:
ISO 50
EXPOSURE:
1/60 second at f11
LIGHTING:
Studio flash fitted with softbox

Direct, diffused and reflected lighting

THE WORD 'PHOTOGRAPHY' literally means drawing with light, and it is the quality of the light – direct, reflected or diffused – that makes the most difference to the surface appearance of the subject. With the majority of household pets, the surface quality you will most want to emphasize is that of the animal's fur or hair.

The three main light qualities you have at your disposal in the studio are direct, diffused and reflected. Direct light is that which reaches the subject directly from the lighting head (flash or tungsten) without any interruption. Diffused light can also be direct, but the light from the head first passes through a scrim, softbox, tracing paper or some other translucent material before reaching the subject. Finally, reflected light is that which is bounced off a wall, ceiling, flash umbrella or some similar object or surface before reaching the subject.

Of these three principal lighting qualities, direct and diffused illumination give results with more 'bite' and, thus, the best surface definition. Reflected light from, say, a flash umbrella, tends to produce the softest type of results and, as a result, the least effective surface definition. However, flash umbrellas can be made out of a variety of materials, and silver-lined types are probably the best compromise for most subjects, giving a broad, shadow-filling illumination without reducing an animal's coat to a dull and featureless shell.

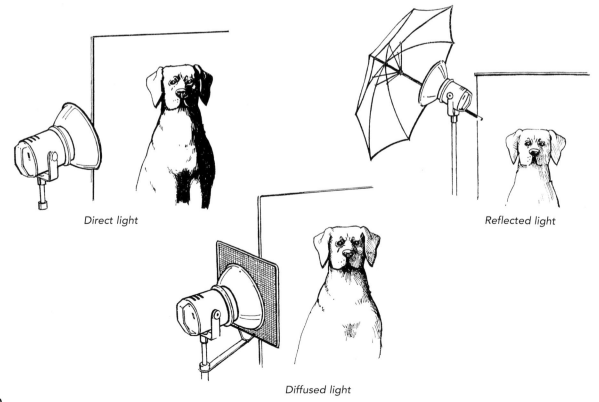

Direct light

Reflected light

Diffused light

The rough-textured corded coat of this puli is a natural candidate for direct flash. The single lighting head used was positioned nearly head-on to the dog and you can see that the shadows are just a little denser toward the rear of the animal. The uncompromising lighting quality of this lighting has maximized surface texture, and you have a real impression of what the dog's coat would feel like simply by looking at the image.

PHOTOGRAPHER:
Paddy Cutts
CAMERA:
6 x 4.5cm
LENS:
90mm
FILM:
ISO 50
EXPOSURE:
⅟₂₅ second at f16
LIGHTING:
Direct studio flash

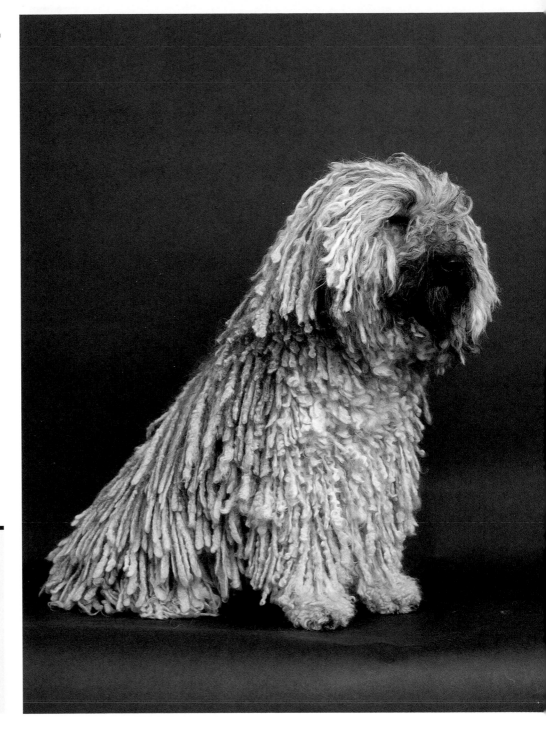

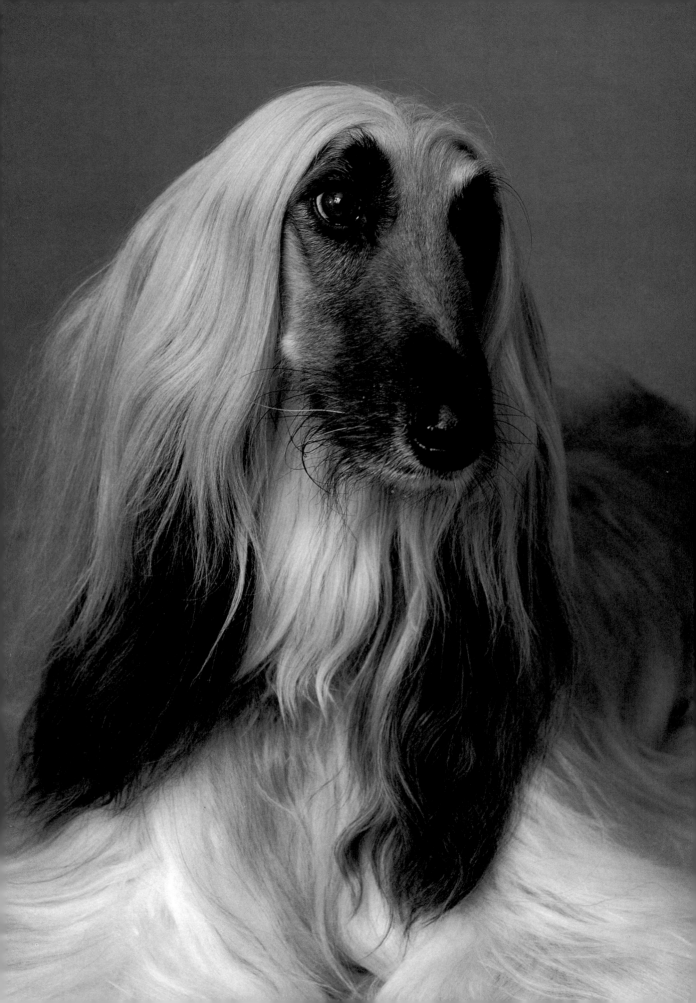

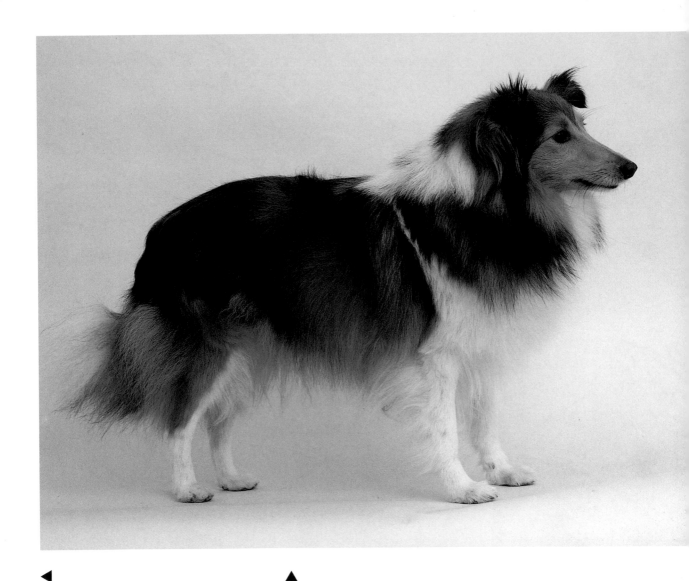

◄

The fine-textured, silky coat of this Afghan hound demanded a less-severe lighting set-up than that used in the shot of the puli. To record the Afghan's finely divided coat it was important to use direct flash, but the output needed to be softened slightly by taping a sheet of tracing paper to the front of the head.

PHOTOGRAPHER:
Paddy Cutts
CAMERA:
6 x 4.5cm
LENS:
120mm
FILM:
ISO 50
EXPOSURE:
¹⁄₂₅ second at f11
LIGHTING:
Diffused studio flash

▲

To light evenly both the subject of this shot – a sheltie – and the background paper, the photographer needed a broad spread of light. The obvious solution in a situation like this is to reflect the light off a convenient surface, such as a wall. The walls of the studio, however, were too distant and they were painted in a matt-finish white that would have 'deadened' the light. Instead, the photographer attached a flash umbrella to the lighting head, selecting a silver-coated type in order to keep the lighting critically sharp.

PHOTOGRAPHER:
Paddy Cutts
CAMERA:
6 x 4.5cm
LENS:
80mm
FILM:
ISO 50
EXPOSURE:
¹⁄₂₅ second at f8
LIGHTING:
Studio flash fitted with a silver-coated umbrella

Lighting direction

THE DIRECTION OF THE LIGHT falling on your subject has a major influence on its final appearance. The advice most often given to a photographer is to stand with the sun at your back – in this way, the light will be falling on the side of the subject facing the camera. From a metering point of view, this type of illumination leaves less chance of getting the exposure wrong, but it often also produces the least interesting lighting effect. When you are working in the studio, for example, it is not very often that you set your lights square-on to the subject. More usually, they will be off-set to one side or the other, or a frontally positioned light will be used in conjunction with a sidelight, toplight, or backlight. Outdoors when you are working with the sun you cannot, of course, change the position of the light, but by repositioning the subject or adopting a different shooting angle you should be able to find the best lighting effect for each particular picture.

Frontlighting

Sidelighting

LIGHTING EFFECTS

- Frontlighting tends to produce a flat type of illumination and because all of the surface of the subject is evenly lit there will be little evidence of either form or texture.

- Sidelighting tends to produce the maximum amount of surface detail and information, giving a strong impression of both form and texture.

- Backlighting is the most difficult to judge exposure for, but it can also produce the most dramatic and startling results. If you want to avoid producing a silhouetted effect, take your light reading from the subject shadows.

Backlighting

Although the sun
was high in the sky
when this picture
was taken, the
light falling on
the cat is
predominantly
from the rear.
Backlighting such
as this is likely to
produce a wide
exposure differ-
ence between the
foreground and
background, and
so you must be
careful to open up
the lens aperture
to account for the
fact that the side
of the subject
facing the camera
is in shadow. A
general reading
will probably be
over-influenced by
the mainly bright
background light-
ing and produce a
silhouetted subject.

PHOTOGRAPHER:
Paddy Cutts
CAMERA:
6 x 4.5cm
LENS:
120mm
FILM:
ISO 100
EXPOSURE:
1/60 second at f8
LIGHTING:
Daylight only

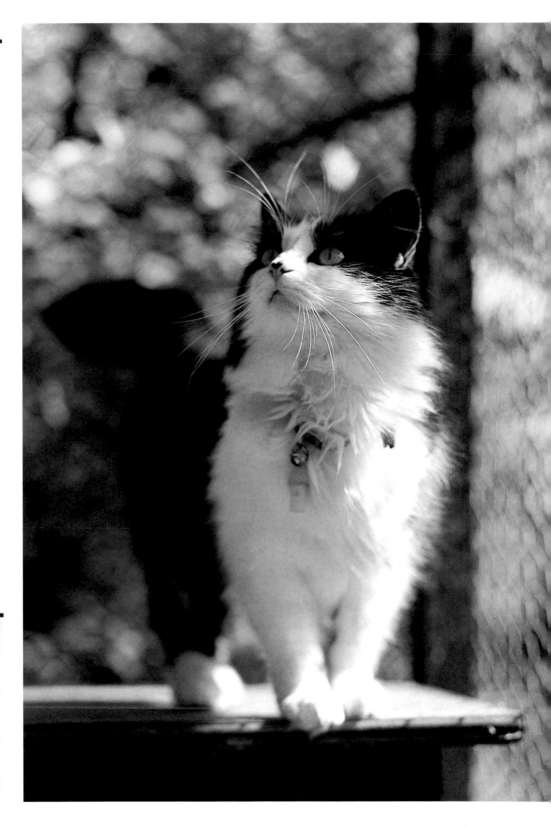

Photographing young animals

PHOTOGRAPHING YOUNG ANIMALS requires a great deal of patience, quick reflexes and, often, quite a bit of wasted film. In general, the younger the animal the less time you will have to work before fatigue sets in and it is overcome with the need to sleep. Also, young animals will not take commands as many adult animals will, and so the onus is on you to stay constantly on the alert for that turn of the head, for example, the direction of the gaze or the lifting of a paw that will help to raise your photograph out of the category of a rather ordinary record shot.

Food is often a great incentive for animals to cooperate, and this is also true for young animals. If the animals are weaned, keep a selection of titbits handy to encourage them into a particular position or to hold still long enough for you to take a few exposures (but make sure the food is removed or excluded from the image area before you take the shot). Always check with the animals' owners, however, that they approve of any food your offer. Water or milk will also be useful during breaks in shooting to offer to any thirsty animals. And if the photographic session is likely to carry on for a prolonged period of time, you will certainly have to provide your subjects with litter trays or give them access to a secure area outside in which they can relieve themselves.

▼

If young animals, such as these two slightly bemused-looking spaniel pups, are feeling a little insecure in the unfamiliar surroundings of the photographer's studio, they will often draw some comfort from being put together in front of the lights.

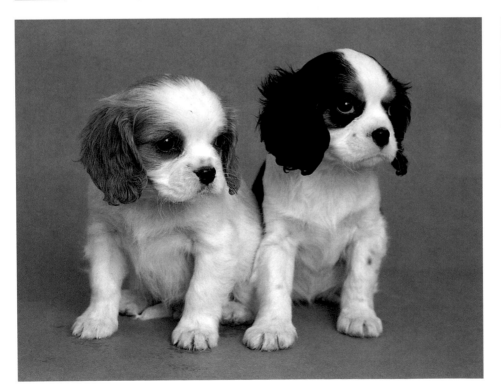

PHOTOGRAPHER:
Paddy Cutts
CAMERA:
6 x 4.5cm
LENS:
90mm
FILM:
ISO 50
EXPOSURE:
1/60 second at f11
LIGHTING:
Studio flash and flash umbrella

▼ ►

When shooting these English setter pups, the photographer was distracted and didn't know that one of the pups was yawning (right). Luckily, she had taken a back-up (below), and this shot proved to be the winner.

PHOTOGRAPHER:
Paddy Cutts
CAMERA:
6 x 4.5cm
LENS:
120mm
FILM:
ISO 50
EXPOSURE:
1⁄60 second at f11
LIGHTING:
Camera-mounted accessory flash

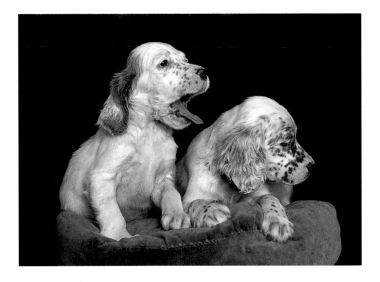

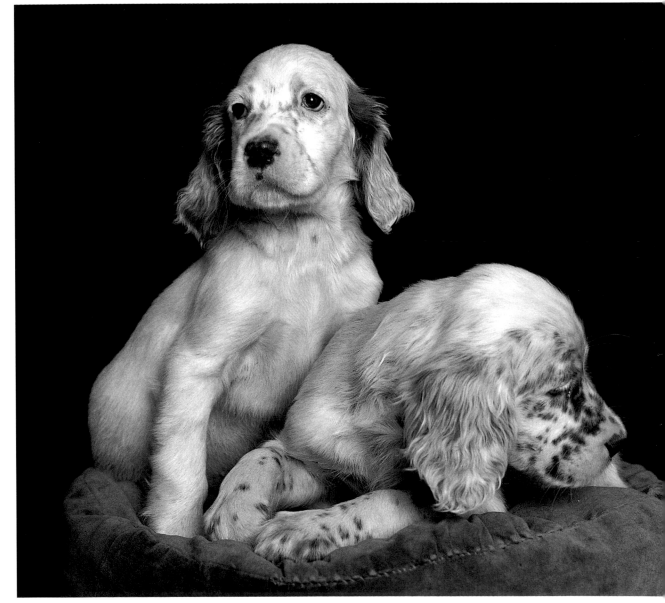

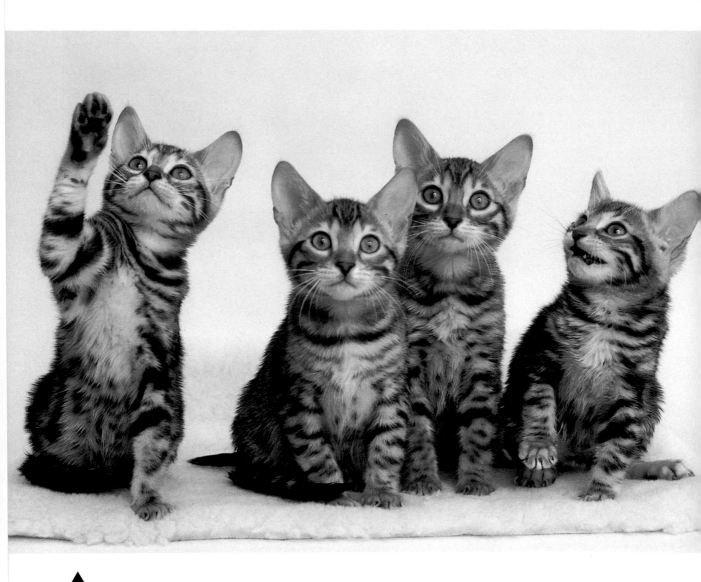

This group of very alert-look Bengal kittens proved to be extremely cooperative. Once positioned on the prepared set they simply sat there staring intently at the activity going on behind the camera. However, the photographer asked their owner to move over to one side of the group, just out of the view of the lens, and to attract their attention on a prearranged signal. Two of the kittens responded, but the middle two were not going to be that easily distracted.

PHOTOGRAPHER:
Paddy Cutts
CAMERA:
6 x 4.5cm
LENS:
150mm
FILM:
ISO 50
EXPOSURE:
1/60 second at f22
LIGHTING:
Studio flash with flash umbrella and reflector

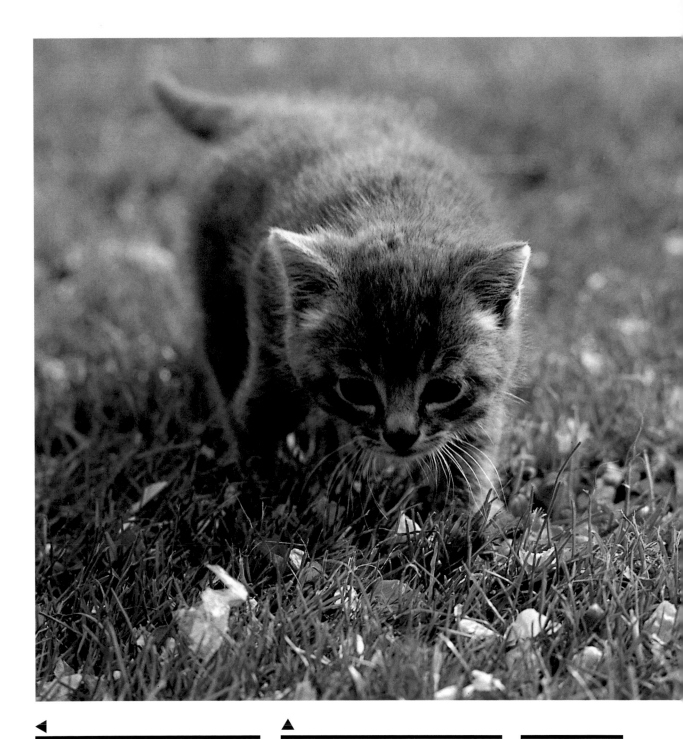

◄

To take the picture opposite, the photographer positioned one studio flash unit – fitted with a reflective flash umbrella to soften the lighting effect – off to one side, on the right of the camera. In order to prevent contrast becoming too extreme, a large, white-coloured cardboard reflector was positioned on the far side of the group to catch and return some of the illumination and so brighten the shadows.

▲

In this informally composed photograph it is the use of depth of field that makes the shot that little bit special. By selecting an appropriate aperture and carefully focusing on the kitten's face, the rest of the image has been graded off into a soft, attractive blur.

PHOTOGRAPHER:
Paddy Cutts
CAMERA:
35mm
LENS:
135mm
FILM:
ISO 100
EXPOSURE:
½₅₀ second at f4
LIGHTING:
Daylight only

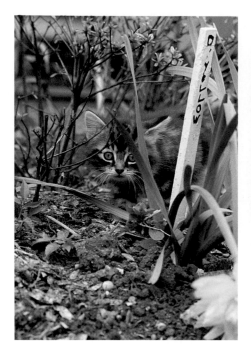

▲

The obvious appeal of this photograph has been increased further by introducing a sense of scale. By including objects of sizes known to the viewer – the daffodil flower and plant-name tag – the diminutive size and the seeming vulnerability of the kitten has been strongly emphasized.

PHOTOGRAPHER:
Paddy Cutts
CAMERA:
35mm
LENS:
50mm
FILM:
ISO 100
EXPOSURE:
1/25 second at f8
LIGHTING:
Daylight only

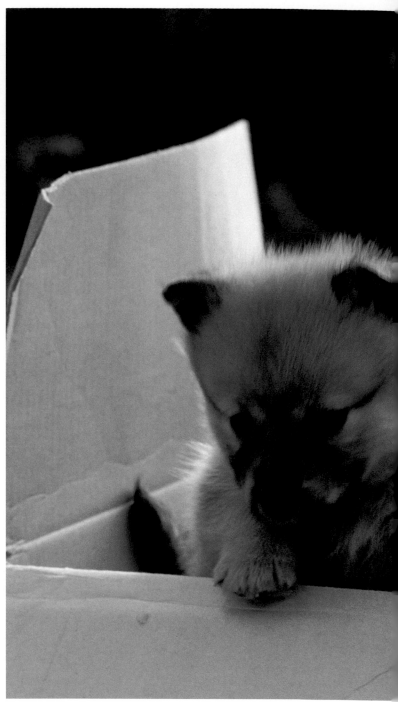

▲

One way to keep a litter of Finnish spitz pups that are full of fun and energy in one place long enough to take their picture is to confine them in some way – here, in an ordinary cardboard box. Informal shots such as this are great fun and are loaded with appeal for the animals' owners.

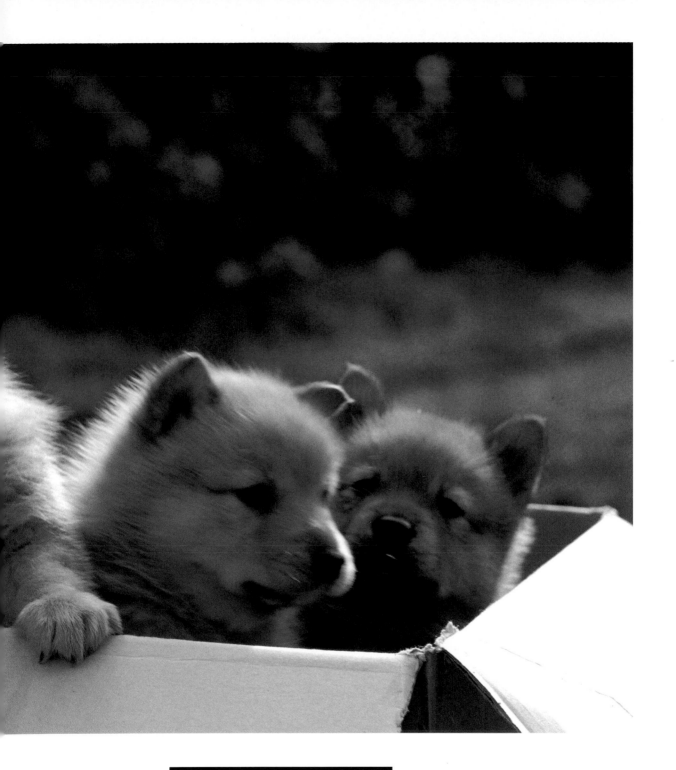

PHOTOGRAPHER:	FILM:
Paddy Cutts	**ISO 100**
CAMERA:	EXPOSURE:
35mm	**¹⁄₆₀ second at f8**
LENS:	LIGHTING:
90mm	**Daylight only**

Small mammals

▼

With a pale-coloured subject, such as this white ferret, choose a background colour that thrusts it forward in the frame and helps to define shape and form. Ferrets are active, curious animals, and the only way to hold this one in position long enough to photograph it was with an offering of food.

ALTHOUGH CATS AND DOGS are far and away the most popular household pets, they are not the only animals you are likely to be commissioned to take pictures of if you are a professional photographer. When children are young, or families are living in apartments or houses with little garden area, people are more likely to keep a range of small mammals as pets. The more common ones include guinea pigs, hamsters, mice, rats, ferrets and even chinchillas. These animals spend nearly all their time confined in cages and so are ideal when domestic space is limited and the only easy access to the world outside may be a balcony.

Essentially, taking pictures of small mammals is no different to shooting cats or dogs. However, because of their size you will probably need to use a longer lens in order to bring the subjects up larger in the frame without approaching too close to the animals.

The trip to the studio itself is likely to upset animals to some degree, as are the strange surroundings once they arrive. So, to keep stress levels down to a minimum: work as quickly as you can and use food and water as an incentive to gain the animals' confidence and cooperation. To speed things up, if possible remove the animal from its cage or travelling-box only once the background paper is in place and the lighting positions set.

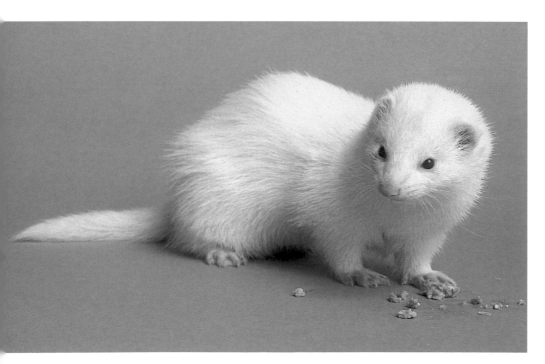

PHOTOGRAPHER:
Paddy Cutts
CAMERA:
35mm
LENS:
150mm
FILM:
ISO 100
EXPOSURE:
$\frac{1}{125}$ second at f11
LIGHTING:
Direct studio flash

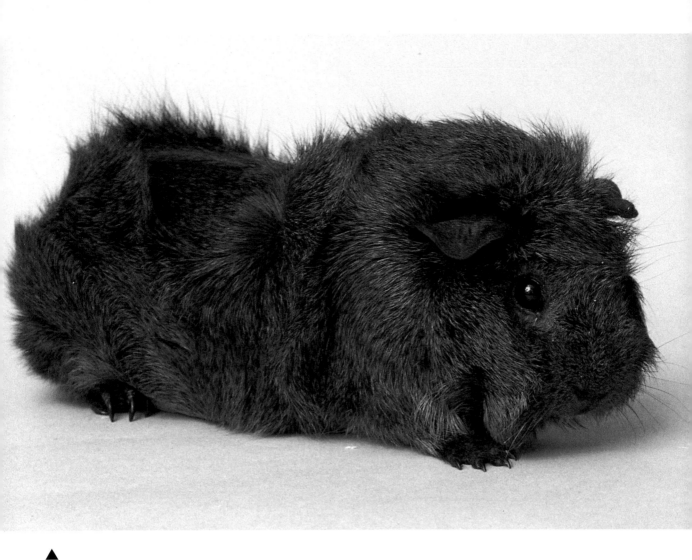

▲

One of the most popular of the small mammals is undoubtedly the guinea pig. These animals vary greatly in size, colouring and hair type (smooth or long-haired), and they are usually good-natured creatures. Once placed in position on the set and stroked a few times to reassure it, this guinea pig proved to be a calm and very cooperative subject.

PHOTOGRAPHER:
Paddy Cutts
CAMERA:
35mm
LENS:
90mm
FILM:
ISO 100
EXPOSURE:
¹⁄₁₂₅ second at f8
LIGHTING:
Diffused studio flash

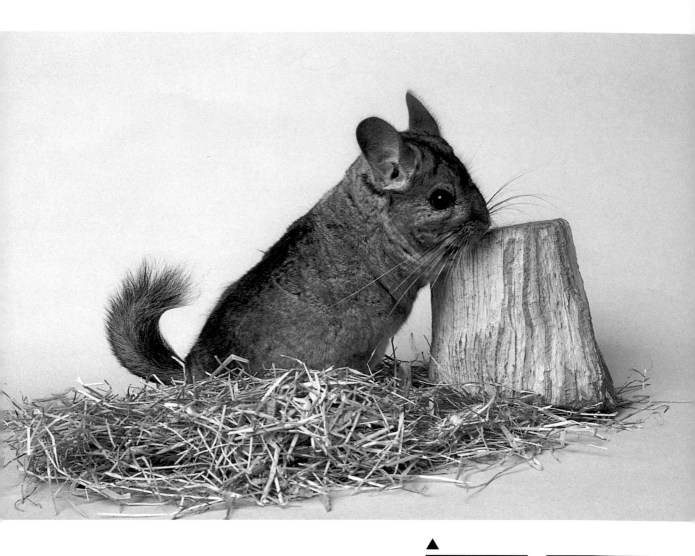

Introducing props
can make a more
interesting
composition than
using just a plain-
coloured set.
However, the
straw and wood
in this picture of
a chinchilla were
from its own cage
and using them
as part of the set
helped to calm
the animal.

PHOTOGRAPHER:
Paddy Cutts
CAMERA:
35mm
LENS:
135mm
FILM:
ISO 100
EXPOSURE:
1/125 second at f8
LIGHTING:
**Diffused studio
flash**

This head-on view of a golden hamster eating was chosen because it showed the tiny animal in its most character-istic and appealing pose. Hamsters are usually nocturnal animals and so the offering of food was essential to bring it fully alert during the day and to ensure that it stayed precisely where it was needed for the lighting set-up.

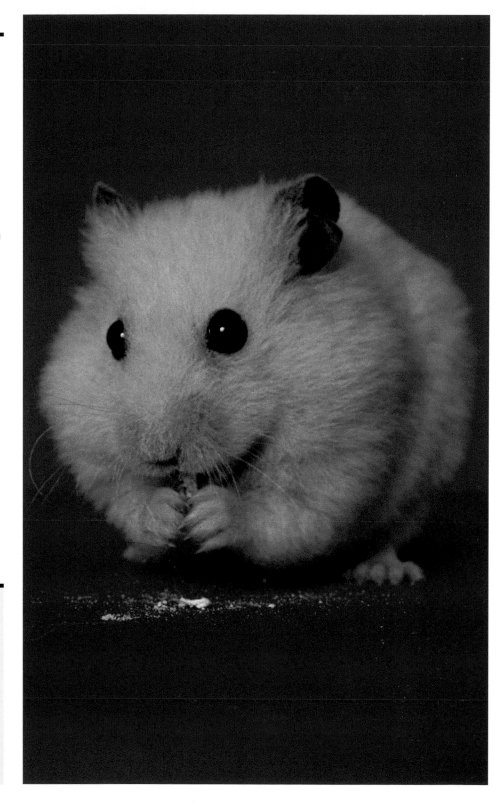

PHOTOGRAPHER:
Paddy Cutts
CAMERA:
35mm
LENS:
150mm
FILM:
ISO 100
EXPOSURE:
1/125 second at f4
LIGHTING:
Direct studio flash

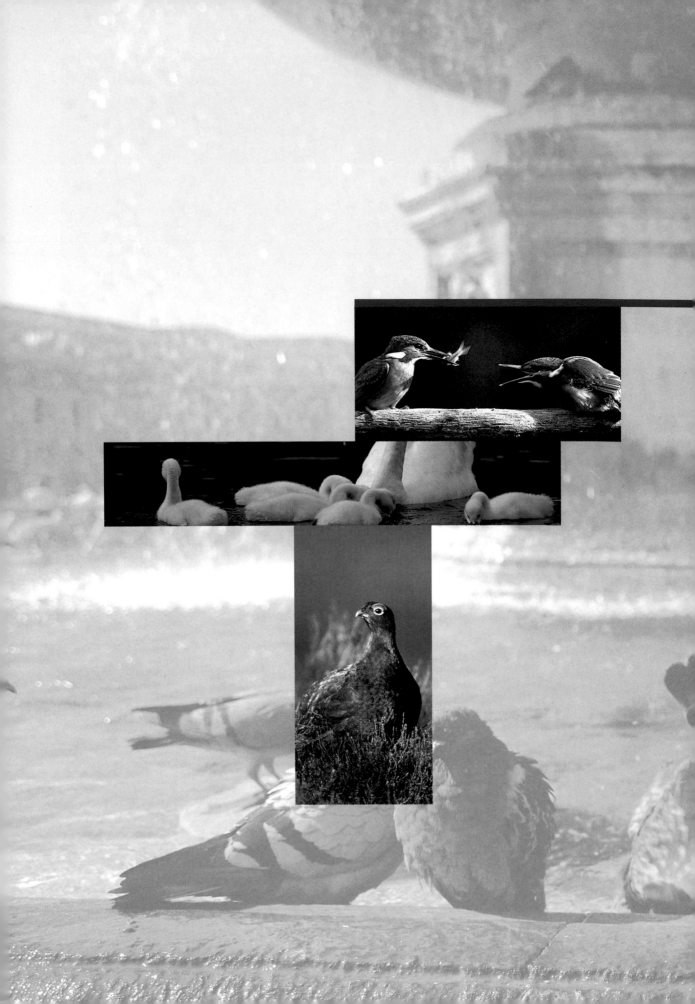

2

LOCAL WILDLIFE

The decisive moment

WHEN PHOTOGRAPHING WILDLIFE SUBJECTS such as birds, the precise instant you press the shutter can make or break the picture. The best way to tackle this type of subject is to set the camera up on a tripod, or some other convenient support, and carefully frame and focus the subject in the viewfinder. Watching through the lens all the time, follow its every movement with the camera, adjusting the focus as it moves nearer or further away from your position. Then, when you see exactly the right composition, taking into account not only the subject but also its surroundings, ease your finger down on the shutter release. If the bird is sufficiently distant, or your camera sufficiently quiet, the shutter firing and the whir of the motor winding the film on should not disturb the subject and you may have the opportunity for extra shots. The factors that determine a successful shot may not be readily discernible at the time of shooting – for example, the turn of a head, the movement of a wing, the glint of sunlight through the trees or off the water may be the important factors, and so the more frames you shoot the better your chances of bagging a winning picture.

▶

SHOOTING WILDLIFE SUBJECTS

- Manual cameras are quieter than those with autowinders or motor drives and are, therefore, less likely to frighten wildlife subjects away after the first frame is taken.

- Practise focusing with your lenses (if they are not autofocus) so that you instinctively know which way to turn the ring to keep a subject sharply framed in the viewfinder as the camera-to-subject distance varies.

- When photographing wildlife, the less you move about the better. A zoom lens allows you a wide range of subject framings, all from the same camera position, and so may be a better bet than a fixed focal length, or prime, lens.

The painterly qualities of this winter scene are striking, as is the restricted colour palette the photographer has employed to produce a near monochromatic composition. If he had exposed the frame just before taking this shot or even a second or two after, one or other of the swans would have been seen against the white of the snow on the shoreline. As it is, both birds are framed against the subdued blue of the still waters.

PHOTOGRAPHER:
Bert Wiklund
CAMERA:
35mm
LENS:
105mm
FILM:
ISO 100
EXPOSURE:
⅟₆₀ second at f16
LIGHTING:
Daylight only

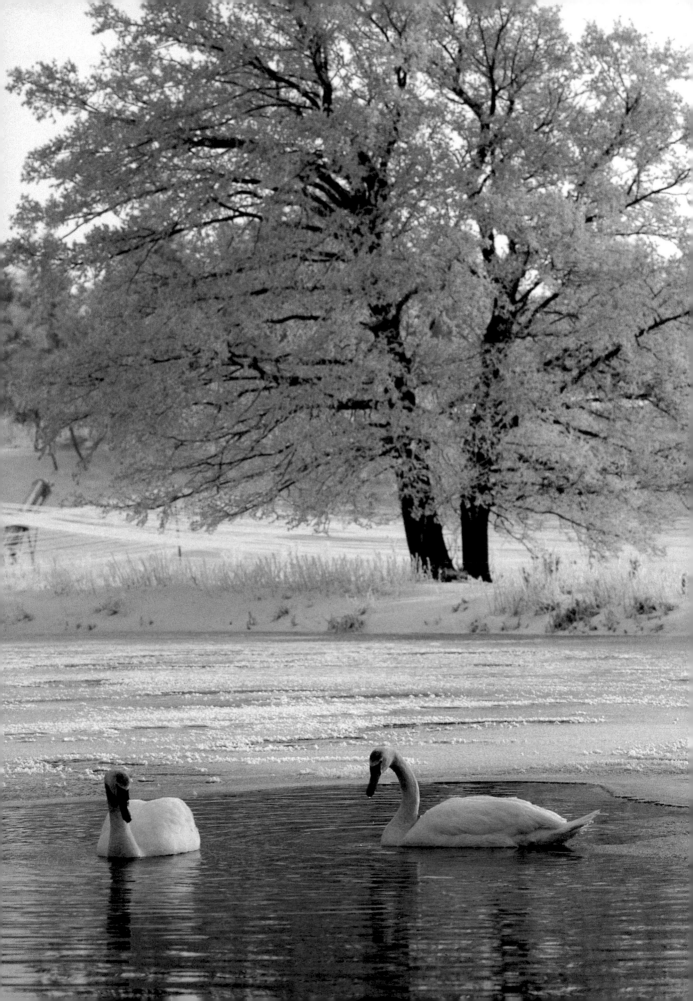

Although the sunlight was bright, it had failed to warm the air of early autumn, when this picture of a family swans was taken. The photographer waited patiently on the shore of the lake with his camera fixed on the adult animal, biding his time until its cygnets gathered around in their search for food. The winning aspect of the shot, however, was when the swan lifted her head from the lake, leaving a trail of water droplets streaming from her bill.

PHOTOGRAPHER:
Bert Wiklund
CAMERA:
35mm
LENS:
300mm
FILM:
ISO 200
EXPOSURE:
$\frac{1}{250}$ second at f8
LIGHTING:
Daylight only

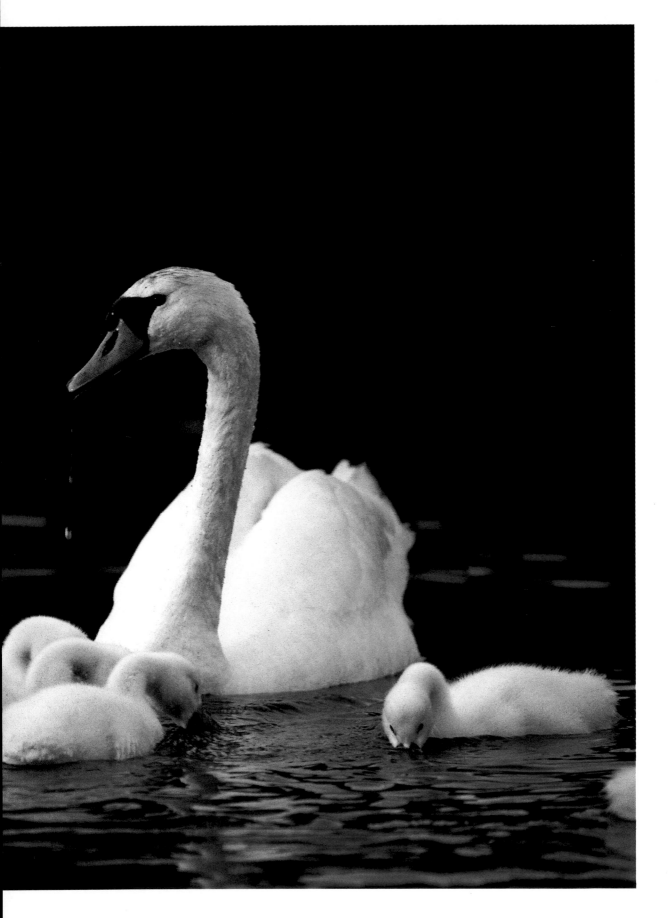

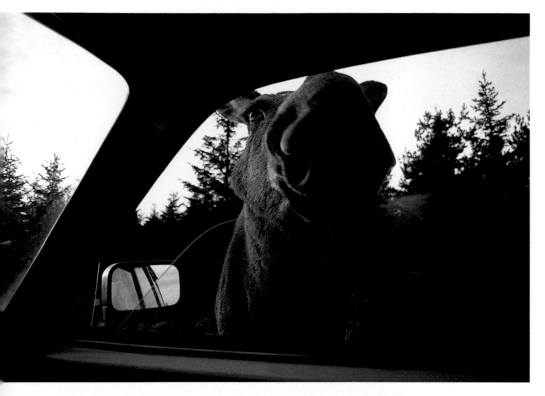

For most of us, the local wildlife consists of birds, perhaps a fox, a few reptiles and a selection of small mammals. For others, however, creatures slightly larger are a daily sight, such as this moose who poked its head through the open car window, looking for a free handout of food to supplement its foraging.

PHOTOGRAPHER:
Bert Wiklund
CAMERA:
35mm
LENS:
28mm
FILM:
ISO 200
EXPOSURE:
$\frac{1}{125}$ second at f11
LIGHTING:
Daylight only

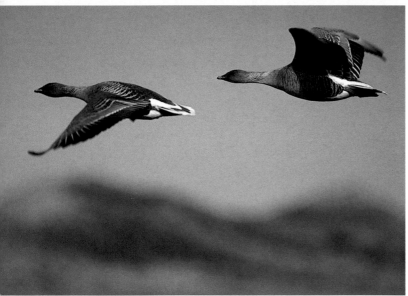

The faster the subject is moving, the briefer the shutter speed you need to select if you want to freeze its movement. However, choosing the precise moment in which to trip the shutter to record, as here, the beating wings of a pair of geese, has to be largely a matter of luck and guesswork. In this type of situation, it is best to follow through with the camera, exposing a series of frames, and then you can select the best shot one after the film is processed.

PHOTOGRAPHER:
Bert Wiklund
CAMERA:
35mm
LENS:
210mm
FILM:
ISO 100
EXPOSURE:
$\frac{1}{500}$ second at f5.6
LIGHTING:
Daylight only

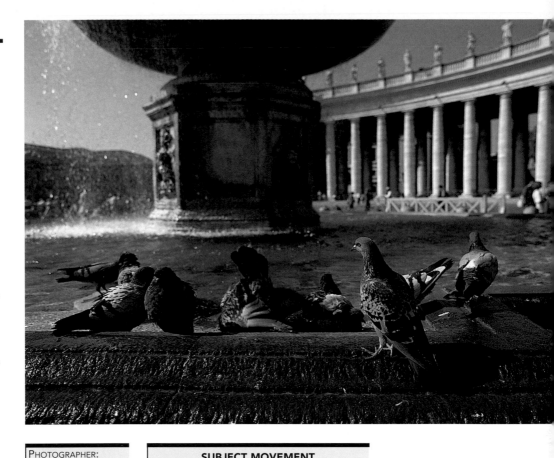

Even the most ordinary of subjects can be transformed into the nucleus of an excellent picture. Here, the photographer has taken as his subject a flock of ordinary pigeons drinking and bathing in the cooling water of a fountain in the heart of Rome. Moving in close with a wide-angle lens, he waited, finger poised over the shutter-release button, for the pigeon in the immediate foreground to walk into the frame. You can see for yourself how important that pigeon is to the overall composition – cover it up with your finger and note how flat the picture immediately becomes.

PHOTOGRAPHER:
Bert Wiklund
CAMERA:
6 x 7cm
LENS:
50mm
FILM:
ISO 50
EXPOSURE:
$\frac{1}{25}$ second at f8
LIGHTING:
Daylight only

SUBJECT MOVEMENT

- Subject movement is most apparent when the direction of travel is at 90° to the camera position.
- Subject movement either directly toward or away from the camera is least noticeable when recorded.
- Subject movement at 45° to the camera position is a compromise in terms of its appearance in a photograph.
- The longer the lens (and, hence, the larger the subject in the frame), the more noticeable subject movement becomes.

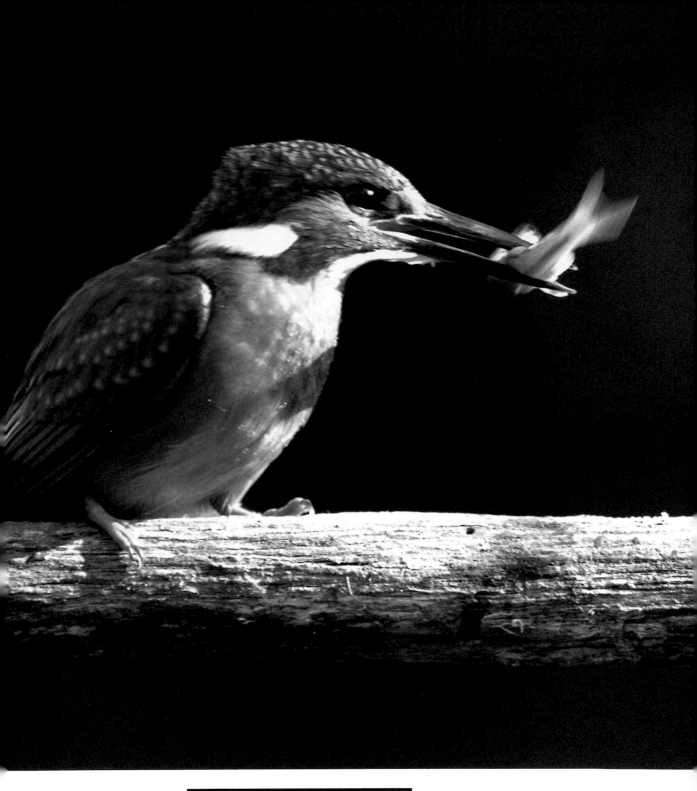

PHOTOGRAPHER:
Roy Glen
CAMERA:
35mm
LENS:
400mm

FILM:
**ISO 100 (pushed 1
stop in processing)**
EXPOSURE:
½₂₅ second at f11
LIGHTING:
Daylight only

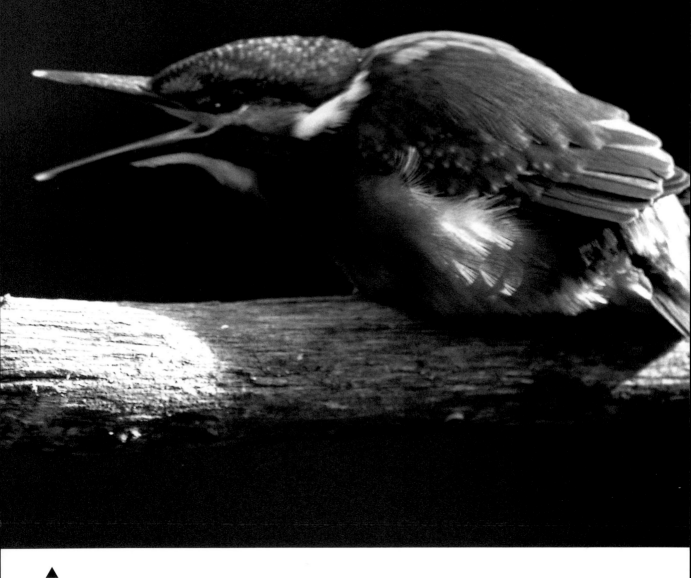

It is easy to see the decisive moment at work in this photograph of kingfishers. The photographer first noticed the two birds flying in and watched the parent bird (proffering the fish) 'park' the juvenile on this branch overhanging the river below.

The adult then flew down to the water but the photographer kept his telephoto lens trained on the juvenile, and just waited. His patience was reward a few minutes later when the adult returned with the minnow to tempt its hungry offspring.

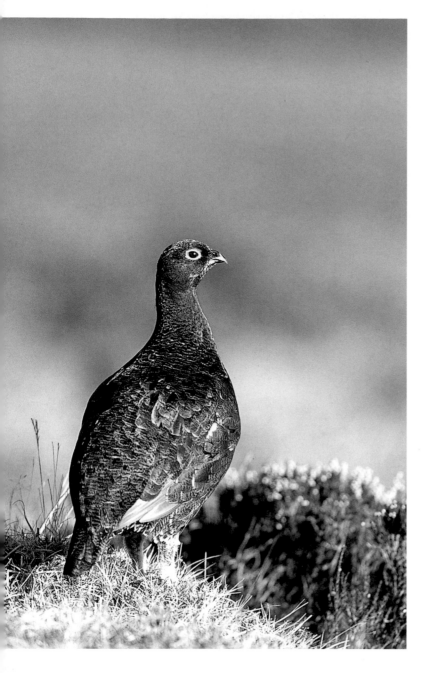

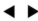

Unless you know your subject well, you may not even be aware that there is a better picture in prospect. The first time the photographer came across this red grouse (left), standing on a grassy mound in the winter December sunshine of northern England, the bird had its back to him. However, knowing what the front plumage of the bird looked like, he took the first, easy shot but continued stalking the grouse, waiting for it to turn around. At last, just as he thought luck had deserted him, the grouse spun around and the photographer got his shot (right).

PHOTOGRAPHER:
Roy Glen
CAMERA:
35mm
LENS:
400mm
FILM:
ISO 100
EXPOSURE:
⅟₂₅ second at f5.6
LIGHTING:
Daylight only

PHOTOGRAPHER:
Roy Glen
CAMERA:
35mm
LENS:
400mm
FILM:
ISO 100
EXPOSURE:
⅟₂₅₀ second at f8
LIGHTING:
Daylight only

Garden birdlife

LIVING IN A TOWN OR CITY should be no bar to you developing an interest in wildlife photography, especially of birds. The diversity of habitat found in many suburbs and, indeed, city centres – with their parks and gardens, and the offerings of food left out on bird tables by kindly wellwishers or simply discarded in the streets as litter – makes these places a rich and rewarding hunting-ground for the alert photographer.

As with all forms of animal and pet photography, the more you know about your target subjects the better your chances of success. For example, certain types of tree will support particular types of bird. Likewise, the nature of the general terrain – open and predominantly grassy, perhaps, or enclosed and protected by tall shrubs, climbers and trees – will either deter or attract certain species of bird. Knowing what you should be looking for in the setting you are working in is a good start, but just as important is having some idea of what birds prefer to eat. All animals are motivated by food, and so offering of favourite titbits will help to attract particular birds into range of your lens, as will water for drinking or bathing in.

GARDEN HIDE

Garden birds soon become used to the presence of people, and some become quite tame. However, others will always maintain a degree of caution whenever people are about and cannot easily be approach with a camera. For these birds, therefore, you need to keep out of sight, and quiet, in some form of garden hide. A 'natural' hide could be a garden shed, for example, a summer-house or playhouse. The only criteria are that the structure should be a normal part of the garden, and therefore familiar to the birds, and that the window, doorway or other type of opening is correctly orientated toward that part of the garden the birds are likely to show themselves. One excellent type of garden hide can be easily constructed simply by throwing a large, old sheet or other material, over a clothes line. Peg out the edges, if necessary, to increase the space inside the tent-like structure. Leave the hide up in the garden for a few days to allow the local birds to be accustomed to its presence before installing yourself and your photographic equipment, and then try to keep traffic to and from the hide to a bare minimum. In cold weather, keep a thermos of coffee in the hide to help keep you alert.

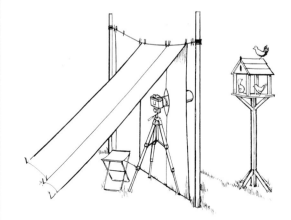

Although smaller than a sparrow, a long telephoto lens has produced a good-sized image of this marsh tit. In winter, most birds appreciate food left out for them, and in this case the photographer baited the pine tree with some sunflower seeds and waited for them to be discovered.

PHOTOGRAPHER:
Roy Glen
CAMERA:
35mm
LENS:
400mm
FILM:
ISO 100
EXPOSURE:
⅟₆₀ second at f4
LIGHTING:
Daylight only

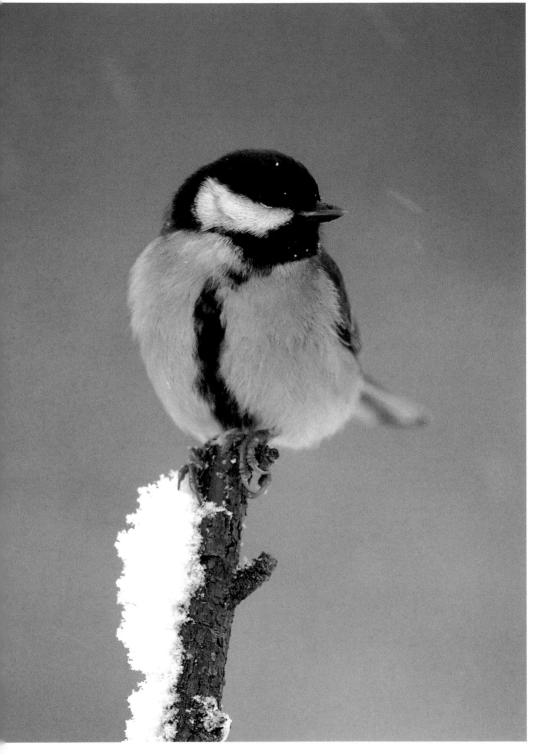

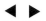

These spring and winter views of great tits illustrate the different qualities seasonal light bring to your work, as well as the value of the setting in which your subjects are photographed. Shooting against the light, as in the winter scene (left), often produces a difficult exposure calculation, while the surrounding foliage in the spring scene (right) is likely to give some degree of colour cast, since much of the light reaching the subject has been filtered by the green canopy.

PHOTOGRAPHER:
Bert Wiklund
CAMERA:
35mm
LENS:
250mm
FILM:
ISO 200
EXPOSURE:
⅟₆₀ second at f5.6
LIGHTING:
Daylight only

PHOTOGRAPHER:
Roy Glen
CAMERA:
35mm
LENS:
400mm
FILM:
ISO 100
EXPOSURE:
⅟₃₀ second at f4
LIGHTING:
Daylight only

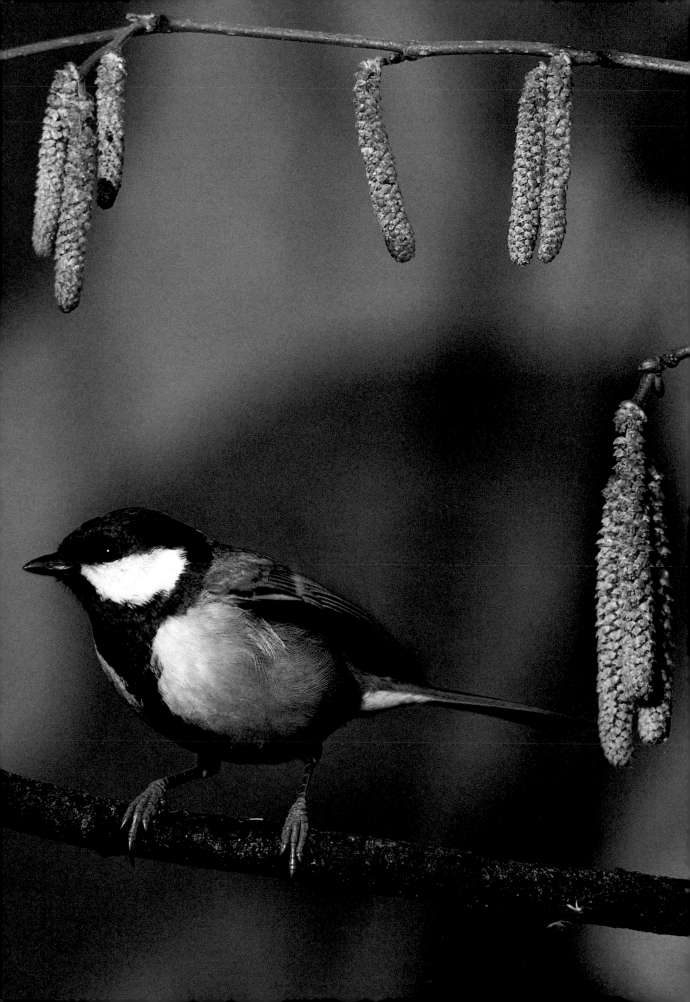

Birds are often creatures of habit, always alighting on the same branch to check for danger, for example, before flying to and entering the nest. The photographer took advantage of the knowledge he had built up through observing this little coal tit, and had set up his tripod-mounted camera and long lens as close as possible to the bird's favourite perch hours in advance of taking this picture.

When the pressure of finding food for ever-hungry and demanding chicks begins to tell, birds that normally fly only at night, such as many species of owl, become increasingly active during the late afternoon and early morning as well. Although an owl's territory is large, as with other birds they all have their preferred routes and observation and resting points. Once you become familiar with your subject's habits you can set your camera up and wait for developments. Patience, however, is an essential prerequisite for success, and you may have to wait for day after day before you get the chance of a shot.

PHOTOGRAPHER:
Roy Glen
CAMERA:
35mm
LENS:
400mm
FILM:
ISO 100
EXPOSURE:
1/125 second at f8
LIGHTING:
Daylight only

PHOTOGRAPHER:
Bert Wiklund
CAMERA:
35mm
LENS:
500mm
FILM:
ISO 100
EXPOSURE:
1/60 second at f8
LIGHTING:
Daylight only

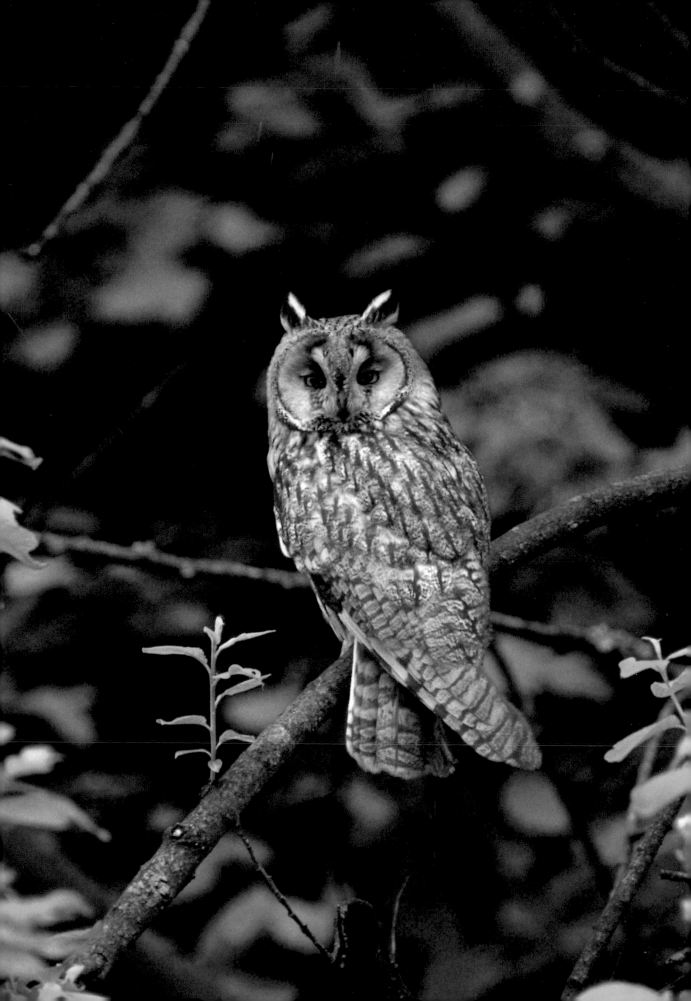

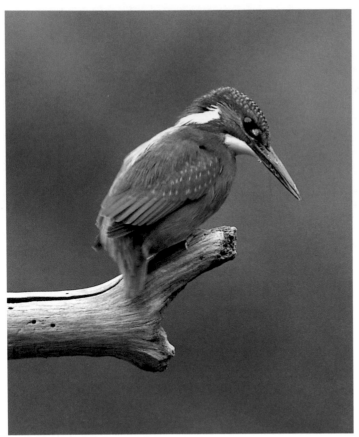

PHOTOGRAPHER:
Roy Glen
CAMERA:
35mm
LENS:
400mm
FILM:
ISO 100
EXPOSURE:
**1/60 and 1/30 second
at f4 and f8**
LIGHTING:
Daylight only

If your garden contains a large area of water, or you have water nearby, you may be lucky enough to get the chance to photograph wonderful birds such as these kingfishers. Again, close observation is necessary to discover where they perch, but they will often return to exactly the same spot after each dive to preen or consume their catch.

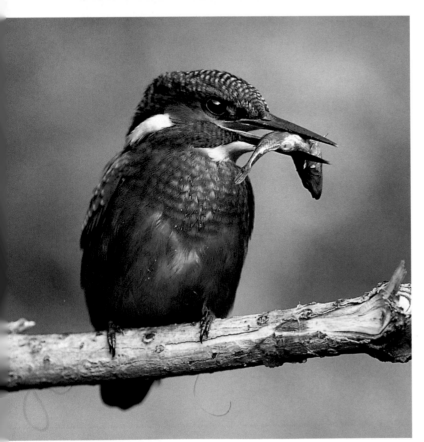

NOTE WELL

In some countries, kingfishers are protected by law and you may need to obtain a licence to photograph within a specified distance of their nesting sites. If you are in any doubt, check with your local bird-protection authority.

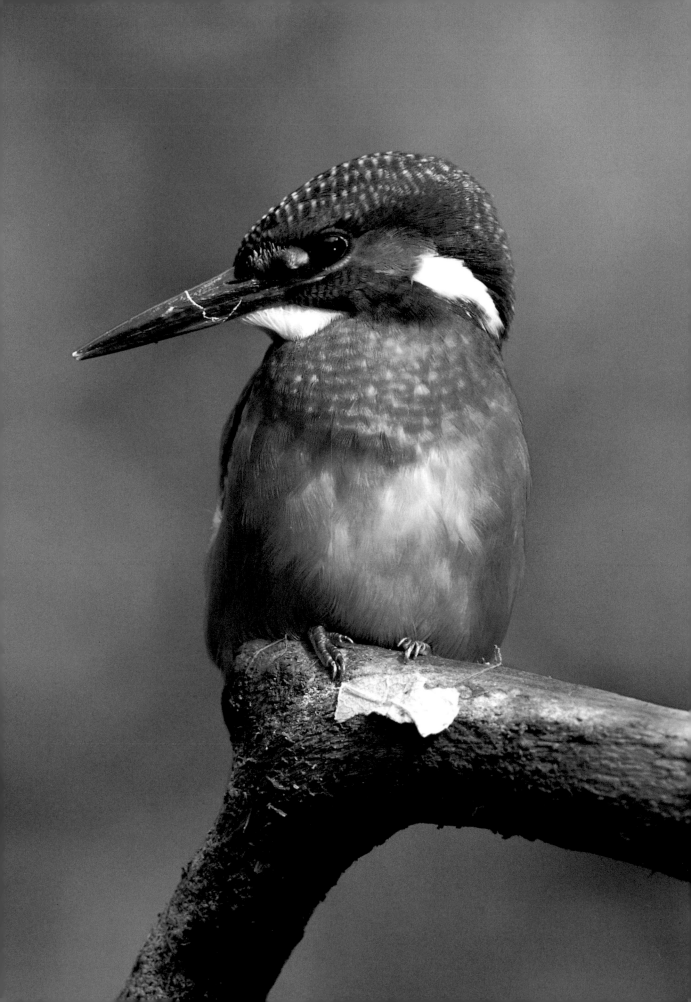

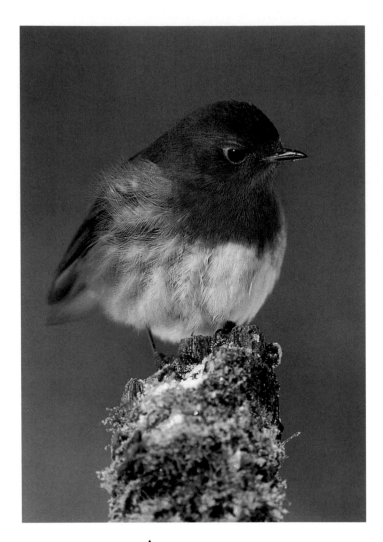

Although the grey heron may seem like an exotic, it is in fact widely distributed around the world. Herons are voracious fish-eaters and many water gardeners know to their bitter disappointment that a single heron can wipe out an entire pond-ful of fish in just two or three early-morning visits. From a photographic point of view, however, the fishing habits of the heron are ideal, since it will stand perfectly still for endless stretches of time, if undisturbed, waiting for a fish to come within range of its lethal, stabbing beak.

PHOTOGRAPHER:
Roy Glen
CAMERA:
35mm
LENS:
210mm
FILM:
ISO 100
EXPOSURE:
⅟₆₀ second at f5.6
LIGHTING:
Daylight only

If there is one bird that seems to have learned that people are good for business – the food business – it is the European robin. Immediately recognized by gardeners as their constant companion while they turn over the soil or cut back foliage, the robin is quick to dart in to see if a tasty worm or grub has been exposed by all the activity. Some robins will even become tame enough to take food out of your hand.

PHOTOGRAPHER:
Roy Glen
CAMERA:
35mm
LENS:
400mm
FILM:
ISO 100
EXPOSURE:
⅟₆₀ second at f5.6
LIGHTING:
Daylight only

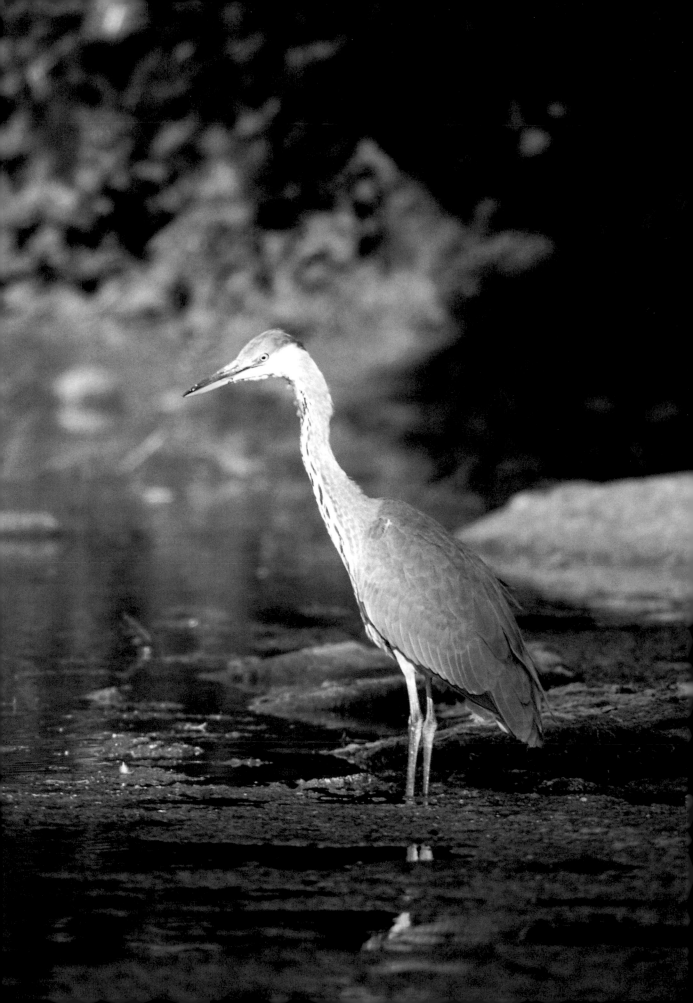

The domestic fox

THE FOX HAS PROVED ITSELF TO BE a resilient as well as an adaptable animal. Persecuted and hunted in many countries as a pest, a carrier of disease or killed for sport, and with its natural habitat eroded by relentless human urban and agricultural encroachment, the fox has responded to these circumstances, which would have driven many other species into extinction, by moving its domestic arrangements into the cellars, sheds and backgardens of suburbia.

Once seen, picked out by car headlights at night, only on the green outer fringes of towns and cities, the modern fox is now a not uncommon sight prowling around urban domestic dustbins in the darkness, feeding on pet food or titbits left out by kindly wellwishers, or taking their ease on the sunny slopes of house roofs at any time of the day.

And some foxes, perhaps orphaned as young cubs, have been successfully integrated into the home, happily sharing their lives not only with people but also with the more usual domestic cats and dogs. Once full-grown, however, a fox can never really be completely domesticated and should be regarded with a degree of caution if you approach too close.

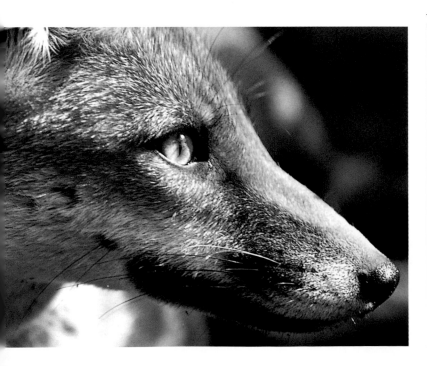

◀ ▶

Photographed from this angle and tightly cropped (left), it would be easy to believe that this were a wild fox recorded using a long lens as the animal sunned itself in a garden. Seen full frame (right), however, you can see a domesticated fox brought up by the family that found it when abandoned as a cub.

PHOTOGRAPHER:
Paddy Cutts
CAMERA:
6 x 4.5cm
LENS:
180mm
FILM:
ISO 50
EXPOSURE:
⅟₁₂₅ second at f5.6
LIGHTING:
Daylight only

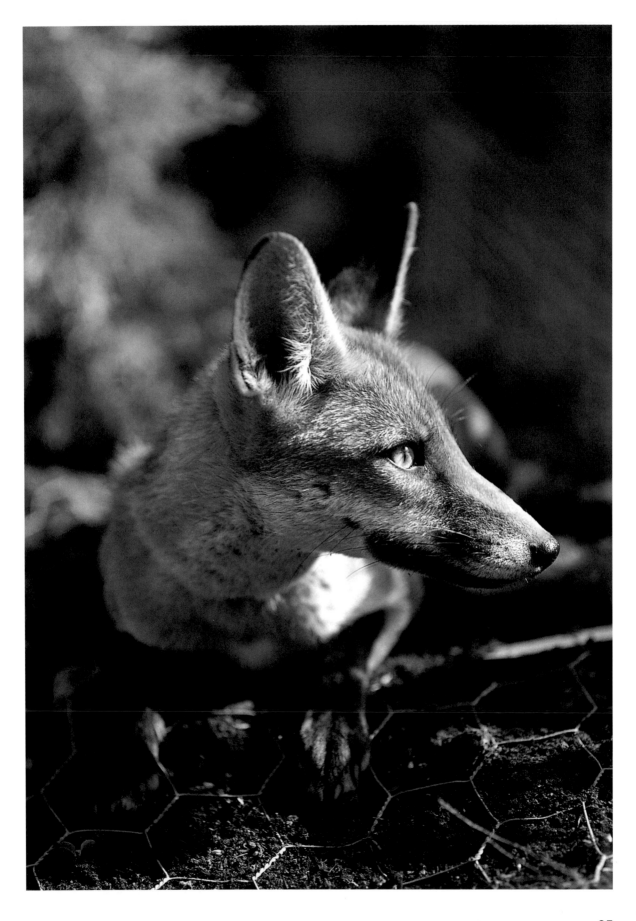

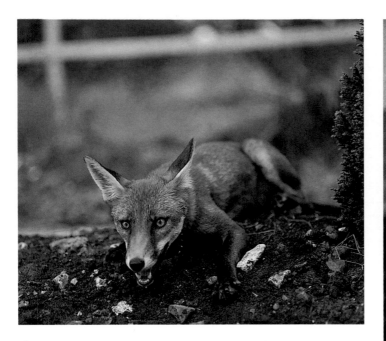

▲

The fox's natural instinct to burrow is evident in this photograph, showing the animal's front legs and muzzle covered in freshly dug soil. The fox's whole posture speaks of energy and alertness, but its eyes tell us that there is absolutely no fear of the photographer's presence.

PHOTOGRAPHER:
Paddy Cutts
CAMERA:
6 x 4.5cm
LENS:
120mm
FILM:
ISO 50
EXPOSURE:
1/125 second at f4
LIGHTING:
Daylight only

▶

No, this is not a serious confrontation between two instinctive enemies – it is simply a meeting between two friends amidst a jumble of old building materials in the backyard. These two have known each other all their lives, when as a young cub, the fox was introduced into the home, and they have a perfectly relaxed relationship.

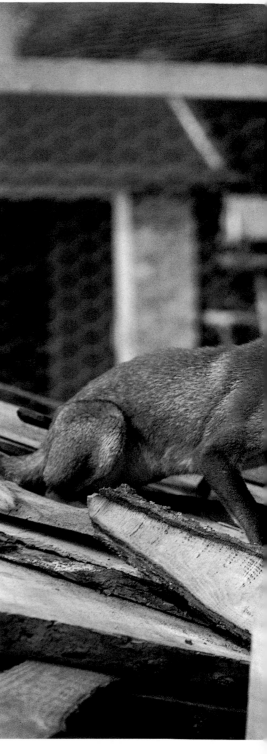

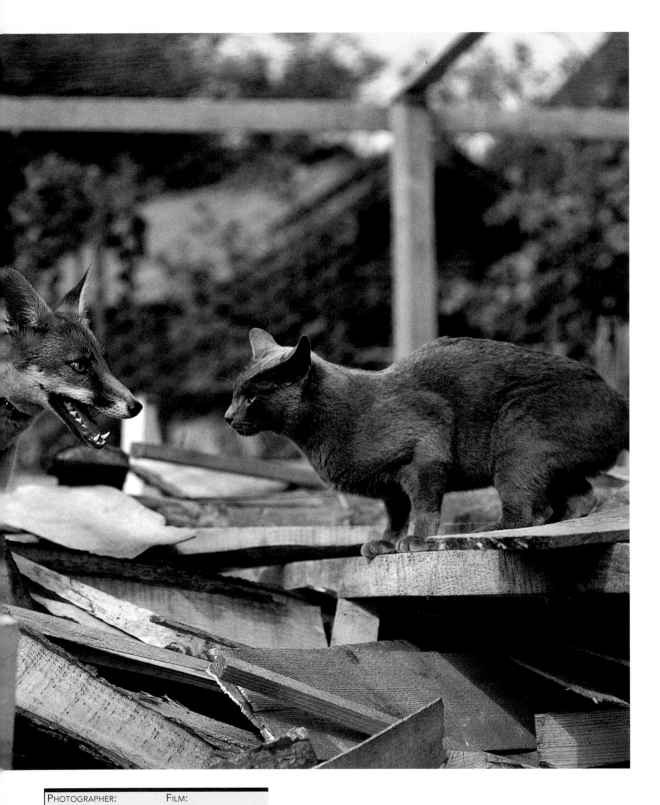

PHOTOGRAPHER:	FILM:
Paddy Cutts	**ISO 50**
CAMERA:	EXPOSURE:
6 x 4.5cm	**¹⁄₆₀ second at f8**
LENS:	LIGHTING:
120mm	**Daylight only**

3

FARM AND WORKING ANIMALS

Choosing lenses

THE TYPES OF LENS YOU NEED to pack into the back of the car when you are working on location depend on the type of subjects you are likely to encounter. For wildlife photography, for example, where you will not be able to approach your subjects closely, the best choice of lenses will probably be the more extreme telephoto focal lengths. However, with farm and working animals, which are well used to people and can usually be approached without problems (although caution may be called for in some cases), a better choice of lenses could be a moderate wide-angle, a standard and a moderate telephoto.

For the 35mm format, a moderate wide-angle would be a lens in the range of 35 to 28mm; a standard lens is 50 or 55mm; and the term moderate telephoto takes in a wide range from about 90 to approximately 180mm. As well as having different angles of view and producing varying degrees of subject enlargement, each type of lens also imparts its own particular 'character' to the final image (see box below).

LENS EFFECTS

- Wide-angle lenses produce the widest angles of view compared with the other categories. This makes them ideal for broad landscape-type images, although subject elements may appear diminished unless they are close to the lens. Wide-angles tend to enlarge the immediate foreground and make the background appear small and very distant in comparison.
- Standard lenses are also commonly known as 'normal' lenses, because this focal length produces the type of view of a scene or subject that approximately corresponds to the view seen with your unaided eyes. They do not produce any noticeable distortion of perspective and they are also often the fastest lens you are likely to own – which is extremely useful in poor light conditions, when every extra fraction of a second is welcome.
- Telephoto lenses have the narrowest angles of view of all. This makes their use very obvious – enlarging distant subjects, for example, thereby omitting extraneous information contained within the scene and concentrating the viewer's attention on the real subject. However, telephoto lenses also tend to enlarge the background in relation to the foreground. This can give images a rather 'squashed' perspective with no sense of separation between the foreground, middle ground and background.

Taken with a moderate telephoto lens of 180mm, this image displays many of the characteristics of this type of focal length. Its narrow angle of view has excluded the surroundings, except those in the immediate vicinity of the cow; the background is very out of focus due to the shallow depth of field associated with telephotos; and the middle ground and background both seem to be pressing in on the subject.

PHOTOGRAPHER:
Bert Wiklund
CAMERA:
35mm
LENS:
180mm
FILM:
ISO 100
EXPOSURE:
$\frac{1}{250}$ second at f5.6
LIGHTING:
Daylight only

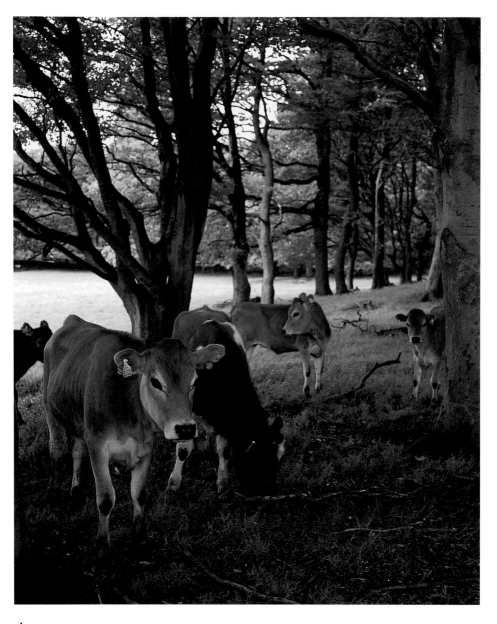

▲

This photograph of cows gathered in the shade of a stand of trees to escape the heat of the day was taken using a standard 50mm lens on a 35mm camera (because of the larger film size, a 'standard', or 'normal', lens for a medium format camera is about 80mm). Note that the relationship of the foreground to the other image planes is what you would expect to see if you were looking at the scene with your unaided eyes.

PHOTOGRAPHER:
Bert Wiklund
CAMERA:
35mm
LENS:
50mm
FILM:
ISO 100
EXPOSURE:
⅟₆₀ second at f11
LIGHTING:
Daylight only

PHOTOGRAPHER:
Bert Wiklund
CAMERA:
35mm
LENS:
28mm
FILM:
ISO 100
EXPOSURE:
⅟₂₅₀ second at f4
LIGHTING:
Daylight only

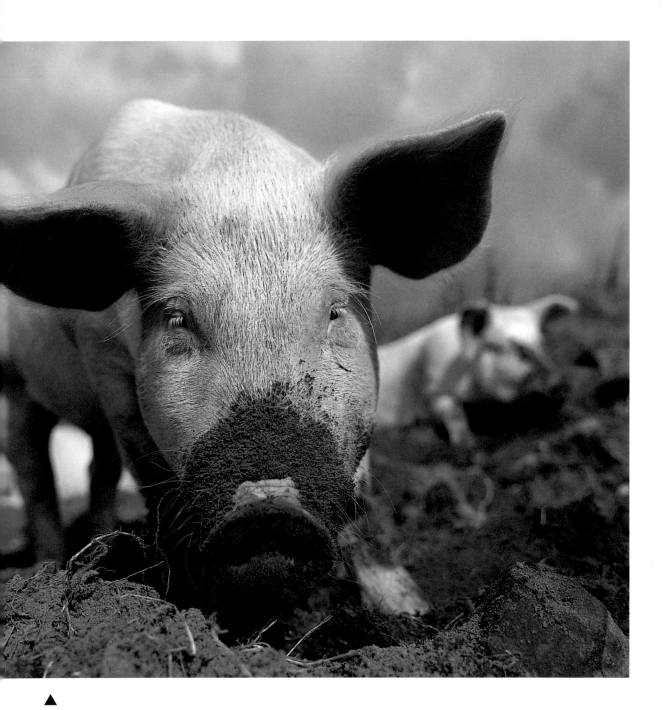

▲

The type of perspective distortion associated with wide-angle lenses is obvious in this photograph of a pig snuffling through the soil looking for a tasty bite to eat. The photographer was lying belly down looking up at the pig as it approached very close to his camera position. The resulting picture shows how the lens has enlarged the immediate foreground and diminished the apparent size of the background.

Animal snapshots

PHOTOGRAPHER:
Paddy Cutts
CAMERA:
35mm
LENS:
120mm
FILM:
ISO 200
EXPOSURE:
¹⁄₆₀ second at f8
LIGHTING:
Daylight only

ALTHOUGH NOT NECESSARILY TAME, most farm and working animals are sufficiently used to people being about that you don't need any special skill to get within camera range of them. However, don't become so fixated on the specific subjects in the viewfinder that you fail to take proper account of their surroundings. In an imaginary, idealized world, 'the farm' conjures an image of attractive rustic buildings, leaded lights, bales of hay stacked against finely weathered wooden walls, and perhaps a cobbled path leading to a stile shaded by an ancient oak – all the elements that make a stunning setting in which to show your subjects.

In reality, however, most farms today are more hi-tech than rural idyll described above. Rather than wooden walls, you are more likely to find corrugated iron; wooden fences will probably have been replaced with low-maintenance metal; cobbled paths with concrete; and your ancient oak was more likely than not felled years ago. If the setting you are confronted with is less than perfect, then eliminate it. Use a low camera angle, for example, to frame your subject against the sky; move in close, and use a long lens, to concentrate attention on the subject alone; manipulate depth of field using the lens aperture ring to control the degree of sharpness of the background, and change the camera position, watching the elements move in and out of the viewfinder, until you see the combination that makes the statement you want your photograph to convey.

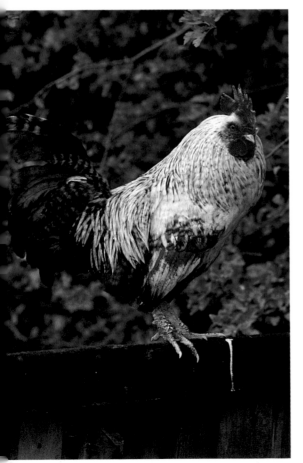

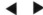

These two photographs of cockerels demonstrate that what you leave out of a picture is as important as what you include. In the first shot (left) the wooden fence the bird was using as a vantage point and the background foliage are both making a positive contribution to the composition. In the other shot, however (right), the grass around the bird was heavily trampled and soiled with animal dung. The solution here was to change the framing and tighten the cropping.

PHOTOGRAPHER:
Bert Wiklund
CAMERA:
35mm
LENS:
135mm
FILM:
ISO 50
EXPOSURE:
¹⁄₁₂₅ second at f4
LIGHTING:
Daylight only

94

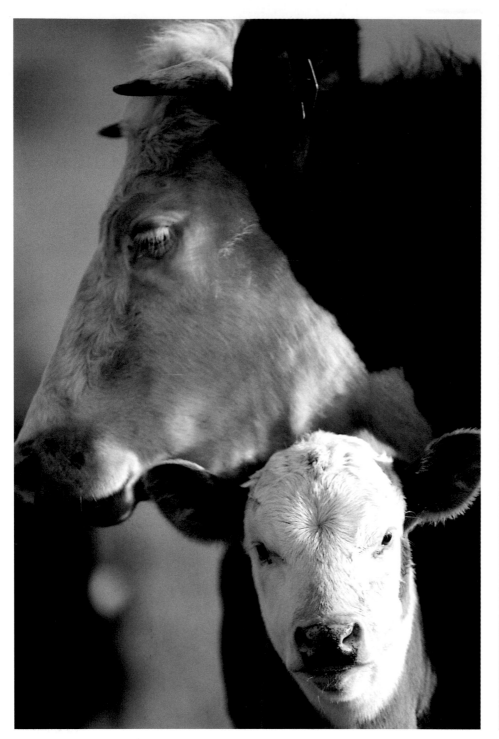

The clear, precise framing you can see in this photograph is a heavily edited version of the actual scene in the field. The field was full of mothers and their calves, many of whom were agitated by the presence of two playfully barking dogs not properly schooled in country etiquette. The real problem lay in trying to obtain an unobstructed view of the subjects, since the other animals were constantly crossing the lens's field of view. Zooming in as tight as his lens would allow in order to eliminate most of the surroundings, the photographer kept his concentration on the viewfinder image but used his peripheral vision to note when a picture opportunity was developing.

PHOTOGRAPHER:	FILM:
Bert Wiklund	**ISO 100**
CAMERA:	EXPOSURE:
35mm	**1/500 second at**
LENS:	**f5.6**
80–210mm (set at	LIGHTING:
210mm)	**Daylight only**

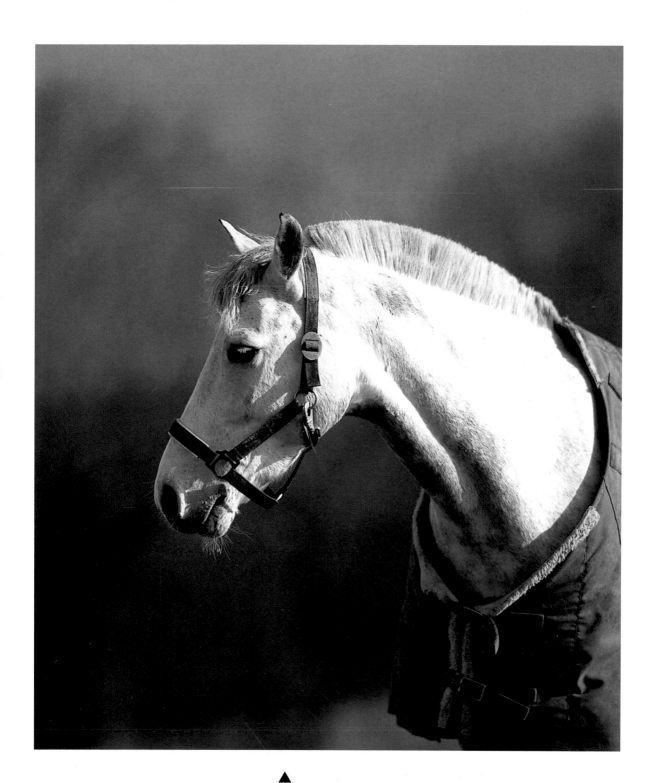

PHOTOGRAPHER:	FILM:
Bert Wiklund	**ISO 50**
CAMERA:	EXPOSURE:
6 x 7cm	**⅛₂₅ second at f5.6**
LENS:	LIGHTING:
250mm	**Daylight only**

In order to take this horse portrait, the photographer bent his knees so that the camera was just slightly lower than it would have been at normal standing height. This brought the distant bare-limbed trees and sky into greater prominence and minimized the presence of the muddy field the animal was standing in.

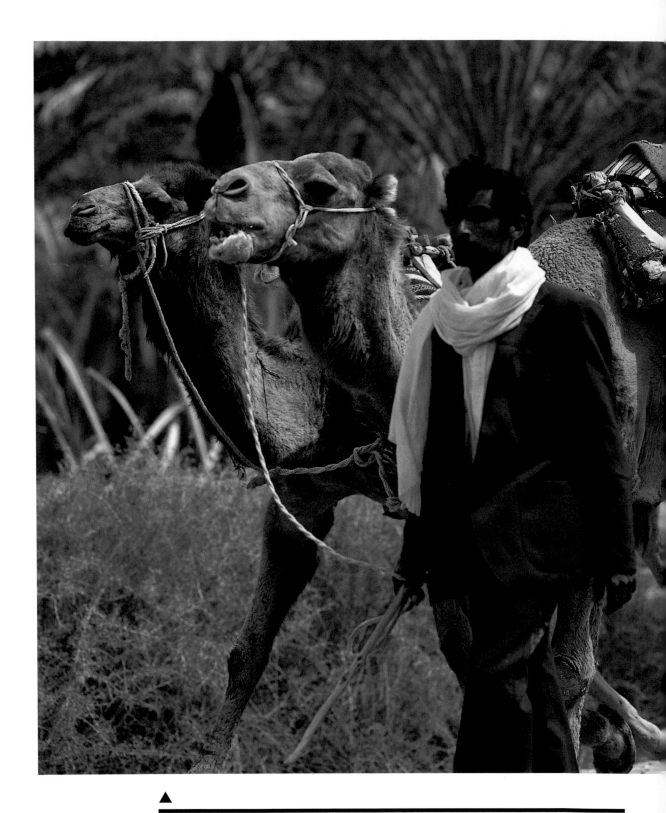

▲

When the setting adds to a photograph's impact, tells you something about the subject and is strikingly attractive, then make the most of it. Taken in Tunisia, where camels are commonly used as domesticated beasts of burden, the photographer carefully adjusted the framing to show the arching fronds of the distant palms, but, by selecting a relatively wide aperture, he also made sure that they were sufficiently out of focus so as not to compete for attention.

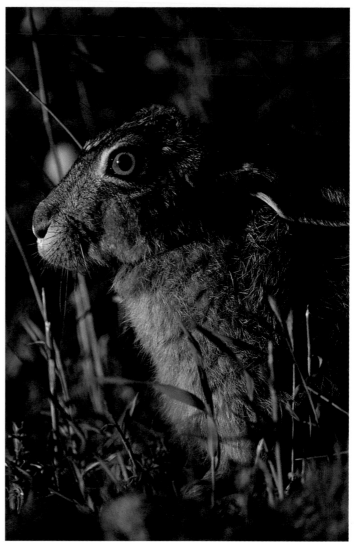

▲

A sharp eye and quick reflexes are important if you want to maximize your picture-taking opportunities. The photographer first noticed the grass moving in a nearby field, although initially he could not see what was causing the disturbance. Moving as carefully and quietly as he could to find a better vantage point, he was rewarded by this sight of a hare resting in the late afternoon sunshine.

PHOTOGRAPHER:
Bert Wiklund
CAMERA:
35mm
LENS:
300mm
FILM:
ISO 50
EXPOSURE:
1/125 second at f8
LIGHTING:
Daylight only

PHOTOGRAPHER:
Bert Wiklund
CAMERA:
6 x 7cm
LENS:
80mm
FILM:
ISO 50
EXPOSURE:
1/500 second at f4
LIGHTING:
Daylight only

Winter lambing

AS PERVERSE AS IT MAY SEEM, nature has decreed that sheep give birth when the weather can be at its coldest and least hospitable. In northern latitudes, lambing often occurs when the ground is still covered in snow and frozen beneath, and you may be trying to take photographs while wearing thick gloves. Also bear in mind that the temperature difference between a warm car and the freezing conditions outside can cause problems for the electronics of automatic cameras, and so you need to allow some time for your camera to acclimatize. In fact, it may be best not to transport your photographic equipment inside the heated interior of a car at all – the unheated boot may be preferable, as long as it is well padded with blankets, or similar material, and your photographic equipment is protected in a shock-proof case.

SNOWY EXPOSURES

A widespread covering of snow can give rise to underexposure. The camera's meter will register all the light reflected from the snow and so may close the aperture down or select a briefer shutter speed (or both) to compensate. However, to be recorded properly your subject may require more exposure than that allowed for by the meter. In these circumstances, you should manually increase exposure above that recommended by your meter, take a selective light reading from your subject or bracket your exposures and select the best examples afterwards.

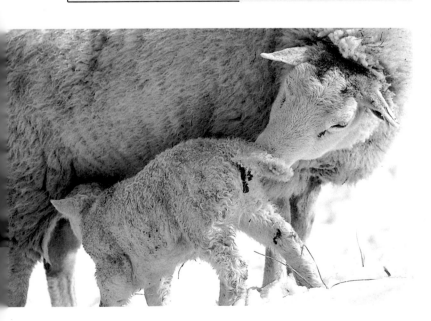

In this shot, the photographer has filled the frame with the ewe and her feeding lamb. Since the subjects take up so much of the frame, a general, or averaging, light reading is likely to result in correct exposure.

PHOTOGRAPHER:
Bert Wiklund
CAMERA:
35mm
LENS:
85mm
FILM:
ISO 100
EXPOSURE:
1/125 second at f4
LIGHTING:
Daylight only

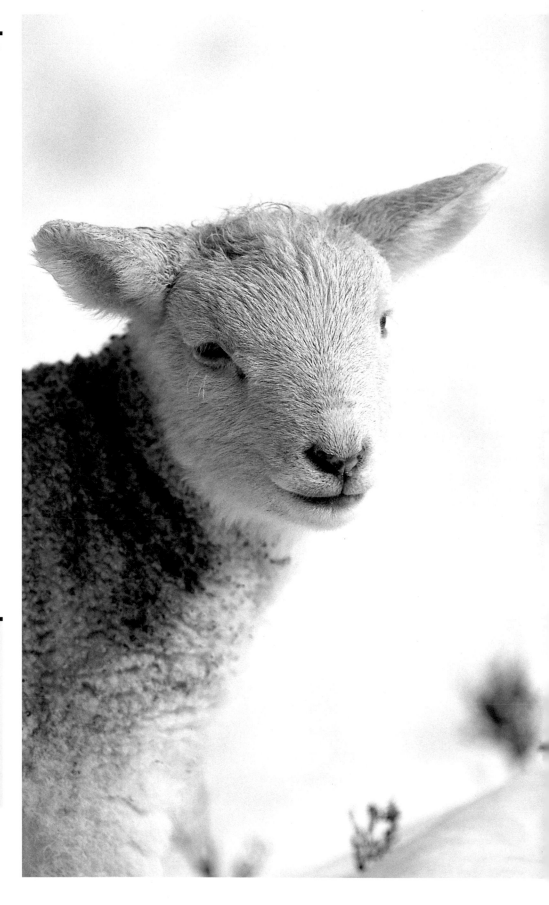

▶
Although you think of lambs as being white, in fact the colour of even a 'white' sheep or lamb is at best a light grey and will, therefore, reflect less light than the surrounding snowy terrain. A general light reading taken in these circum-stances could result in the subject being underexposed.

PHOTOGRAPHER:
Bert Wiklund
CAMERA:
35mm
LENS:
180mm
FILM:
ISO 100
EXPOSURE:
1/125 second at f5.6
LIGHTING:
Daylight only

4

SAFARI AND GAME PARKS

Long lenses

FOR THE TYPES OF WILDLIFE SUBJECTS illustrated below and on the following pages, the most useful lenses you can use are long telephotos. Their value in bringing up distant subjects large in the viewfinder is indisputable. However, there are drawbacks associated with these extreme focal lengths.

The first problem you are likely to encounter with long lenses is their weight. Unless you can select extremely brief shutter speeds, hand-holding is usually out of the question. Even at shutter speeds such as ½₀₀ second or ¹⁄₁₀₀₀ second, the slightest camera movement will result in impossibly blurred images. To overcome this draw-back, it is best to mount the camera on a tripod or, if that is not possible, a monopod is lighter and less bulky to carry and offers a reasonable degree of stability. If all else fails, then rest the camera lens on a branch, the edge of a car, the top of a wall or even a pile of books.

As well as the problem of weight and associated camera movement, another common problem with long focal length lenses is their lack of speed. In this sense, 'speed' refers to widest maximum aperture offered – the wider the aperture, the faster the lens. It is not uncommon for long lenses to have widest maximum apertures of f5.6 or f8. In all but the brightest of lighting conditions, therefore, lenses such as these require shutter speeds that are impossible when hand-holding the camera, or they are too slow to 'freeze' fast-moving subjects. Slow lenses also result in a dim viewfinder, and this can make focusing difficult with manual lenses.

▶

SHUTTER SPEEDS FOR HAND-HELD LENSES

Use the table below as a rough guide for the minimum suggested shutter speed to use when hand-holding a (35mm) camera and telephoto lenses.

FOCAL LENGTH	SHUTTER SPEED
135mm	¹⁄₁₂₅ second
250mm	¹⁄₂₅₀ second
500mm	¹⁄₁₀₀₀ second
1000mm	No safe shutter speed for hand holding

Well fed and sleepy, but still a dangerous animal, this young adult lion was photo-graphed using a long telephoto. The photographer rested the lens on the roll bar of his open-backed four-wheel-drive car, using a bean bag to protect the lens from scratches.

PHOTOGRAPHER:
Roy Glen
CAMERA:
35mm
LENS:
400mm
FILM:
ISO 100
EXPOSURE:
¹⁄₂₅₀ second at f4
LIGHTING:
Daylight only

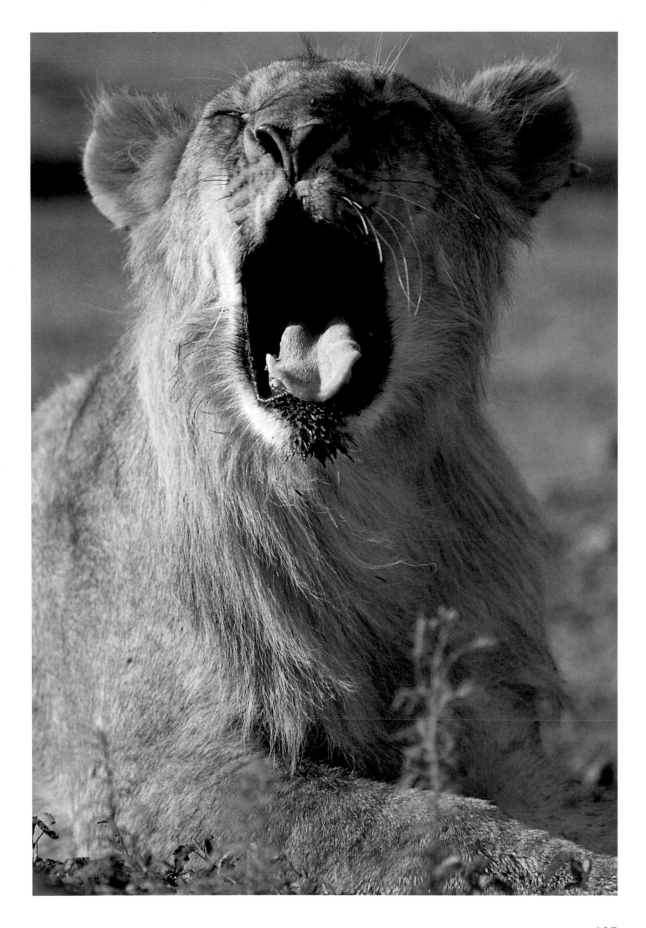

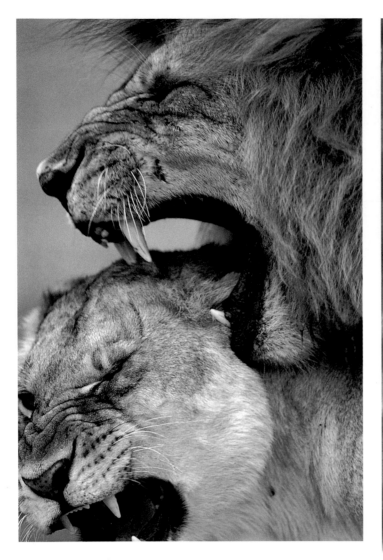

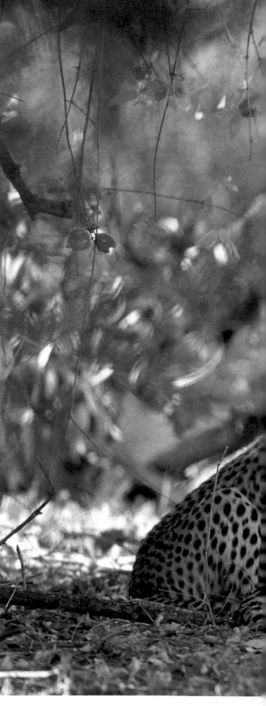

▲

This spectacular facial close-up of a pair of mating lions speaks volumes about the raw, explosive power of these superb animals. Although the attention of the animals was obviously not focused on the movement of the photographer, approaching too close to lions as keyed-up as these two is a dangerous practice. Instead, the photographer used a tripod-mounted camera fitted with a long telephoto lens and converter to double the focal length.

PHOTOGRAPHER:
Bert Wiklund
CAMERA:
35mm
LENS:
400mm (with x2 converter)
FILM:
ISO 100
EXPOSURE:
½₅₀ second at f11
LIGHTING:
Daylight only

PHOTOGRAPHER:	FILM:
Roy Glen	**ISO 100**
CAMERA:	EXPOSURE:
35mm	**⅛₀ second at f4**
LENS:	LIGHTING:
400mm	**Daylight only**

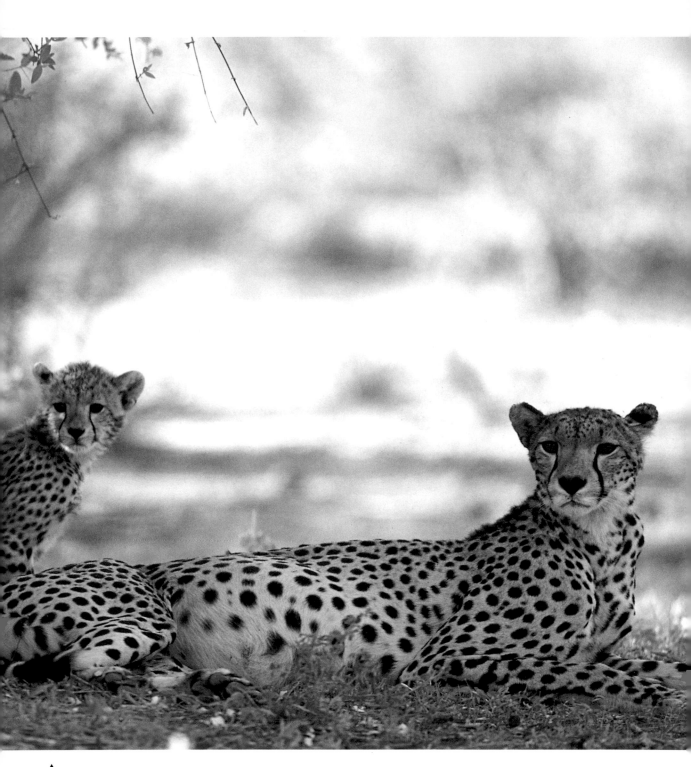

▲

Big cats living in the more popular game and safari parks become accustomed to the presence of tourist vehicles and can usually to be approached quite closely. However, all cats are more wary when they have dependent young to protect, and so a long lens was needed to take this family portrait of a female cheetah and her young cub. To prevent camera shake, the photographer used a monopod.

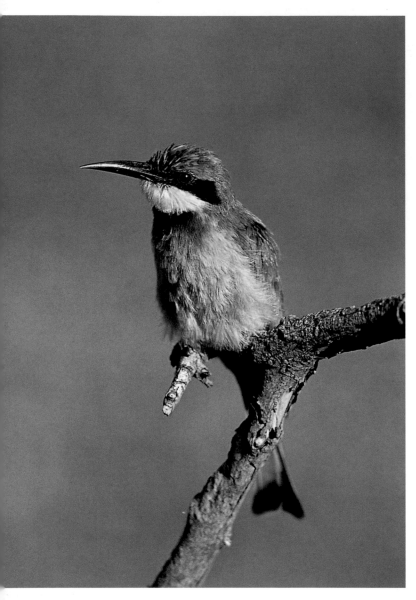

PHOTOGRAPHER:
Roy Glen
CAMERA:
35mm
LENS:
500mm
FILM:
ISO 50
EXPOSURE:
1/125 second at f4
LIGHTING:
Daylight only

▶

Waiting patiently high up in a dead tree for their turn to feed on an impala killed by a lion, this pair of white-backed vultures had to be photographed with a long lens and converter in order to bring the birds up sufficiently large in the viewfinder. Light levels were good and the photographer could thus select a shutter speed brief enough to ensure a perfectly sharp picture while taking a hand-held exposure.

▲

Some animals are wary and simply cannot be approached closely. In these circumstances, there is no option other than to fit the longest lens you have available. To take this shot of a little bee-eater, the photographer used a camera and long lens fitted with a rifle grip in order to prevent camera shake.

PHOTOGRAPHER:
Roy Glen
CAMERA:
35mm
LENS:
400mm (with x1.4 converter)
FILM:
ISO 50
EXPOSURE:
1/500 second at f5.6
LIGHTING:
Daylight only

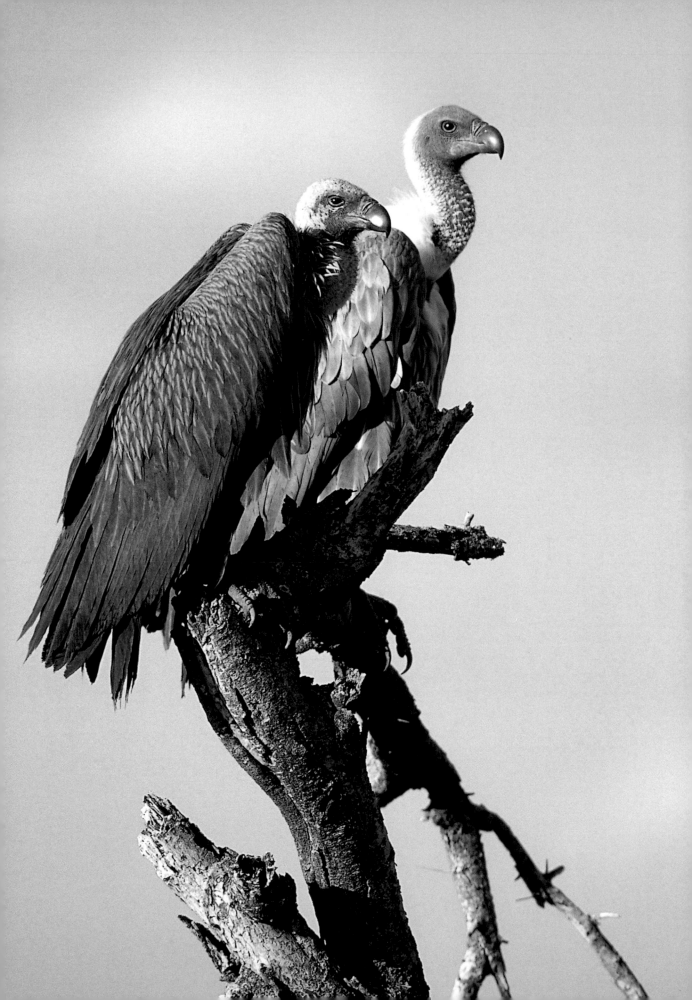

Lighting quality

ONE OF THE PLEASURES, and problems, of working with daylight is its variability. Throughout the day, the quality of light changes from the soft, muted shades of early morning – when the sun is low on the horizon – through to the harsh, often unflattering, contrast of midday – when the sun is more directly overhead – and finally to the warm, sometimes electric colours of dusk as the light from the sun, low in the sky once more, is scattered by the volume of atmospheric particles it has to travel through in order to reach your position.

The quality of light not only depends on the time of day, however – it is also affected by such factors as cloud cover and whether the light reaches the subject directly or it is diffused or reflected by various types of material. For example, light filtering through the tree canopy will have different qualities to that reaching your subject from an overcast sky or light that comes from a sunless but clear blue sky.

LIGHTING CONTRAST

Although light levels are often at their highest at or around midday and so, you would think, advantageous for picture-taking, many photographers eschew this time of day. When the sun is high in the sky and more directly overhead, general views, as well as specific subjects, can appear to consist of adjacent areas of intense highlight and deep shadow. Metering for either of these extremes can be unsatisfactory, since a highlight reading will record shadows as impenetrably dense and lacking in all detail, while a shadow reading will cause highlights to burn out and, even if detail is discernible, subject colouring will be washed out and uninspiring. Taking a compromise reading in an attempt to accommodate the highlights and shadows often results in totally unsatisfactory results for both.

PHOTOGRAPHER:
Roy Glen
CAMERA:
35mm
LENS:
500mm
FILM:
ISO 100
EXPOSURE:
$\frac{1}{25}$ second at f4
LIGHTING:
Daylight only

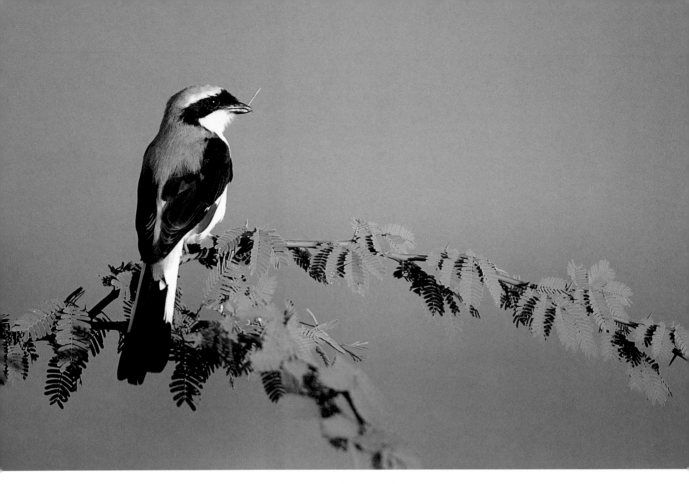

▲ ▶

These two photographs are of a grey-backed fiscal shrike and they show just how strikingly different light at different times of the day can be. In the first shot (above), the bird is sitting on an arching stem and is illuminated by a late morning sun shining from a cloudless blue sky. In the other (right), the shrike is seen in the gentle radiance of early morning sunshine.

Roy Glen
CAMERA:
35mm
LENS:
500mm (fitted with x1.4 converter)
FILM:
ISO 100
EXPOSURE:
¹⁄₂₅ second at f5.6
LIGHTING:
Daylight only

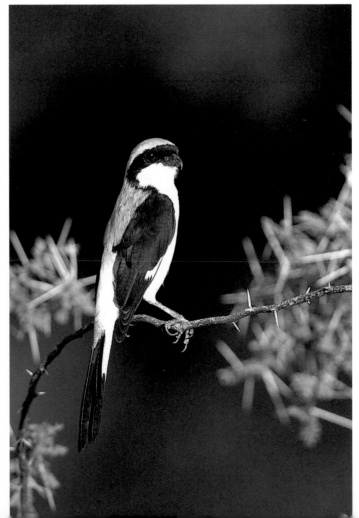

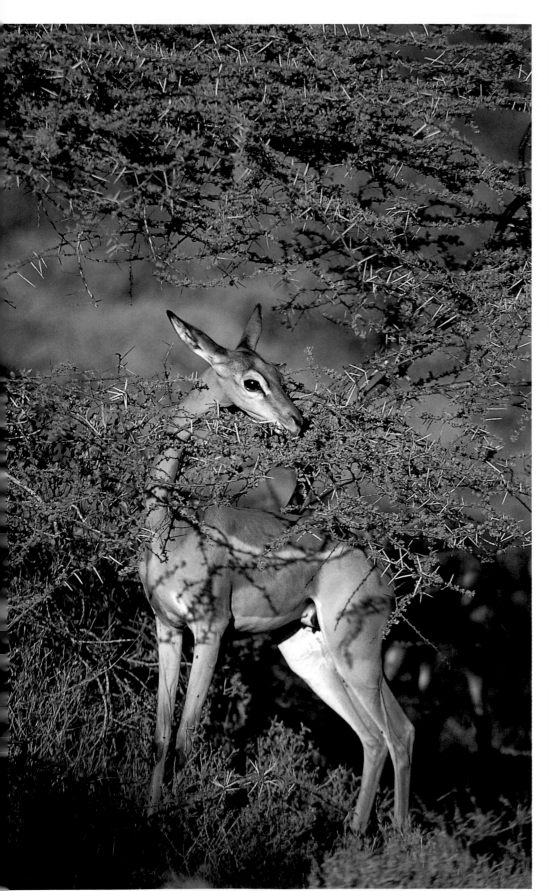

Taken at mid afternoon, the sun has sufficiently passed its highest overhead position to cast intriguing shadows over the gerenuk. Note, too, that although there is contrast between highlights and shadows, it is not so intense that it cannot be accommodated by the exposure.

PHOTOGRAPHER:
Roy Glen
CAMERA:
35mm
LENS:
100–300mm zoom (set at 280mm)
FILM:
ISO 50
EXPOSURE:
½₅₀ second at f5.6
LIGHTING:
Daylight only

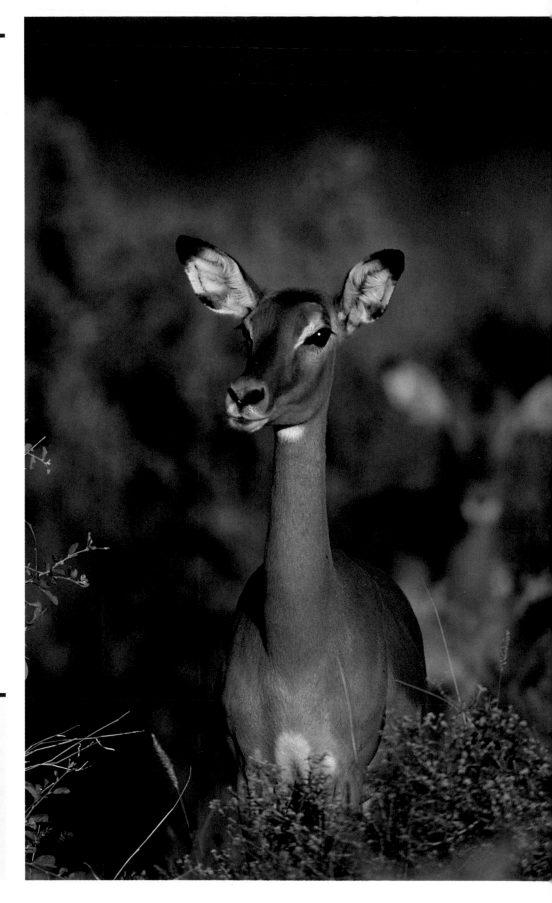

The rosy glow of the last rays of the sun illuminate this impala and bring out the velvety rich texture of its fur. In the tropics, where this picture was taken, the sun sinks very quickly at the end of the day, and you do not have the leisurely dusk and twilight period encountered in more temperate latitudes.

PHOTOGRAPHER:
Roy Glen
CAMERA:
35mm
LENS:
500mm
FILM:
ISO 50
EXPOSURE:
1/25 second at f5.6
LIGHTING:
Daylight only

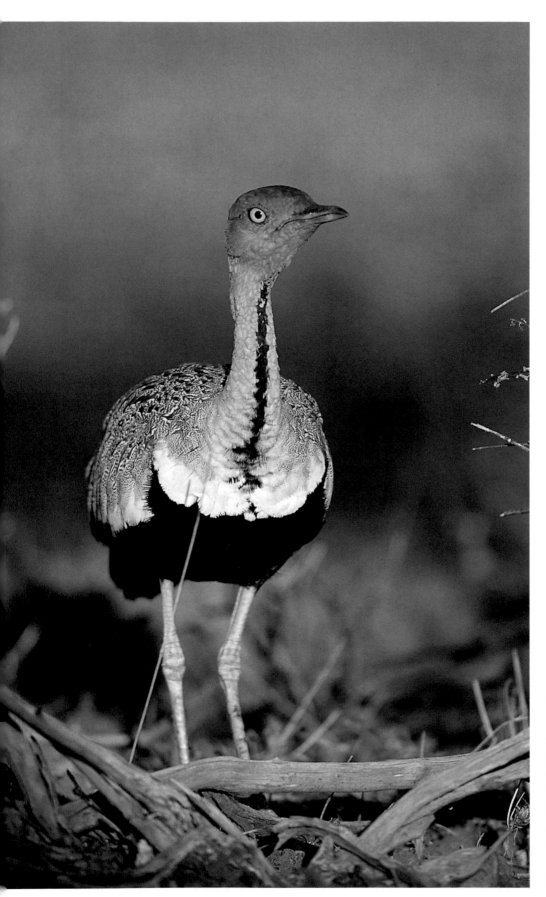

Soft, shadow-filling light is not uncommon early in the morning, especially after the sun has climbed high enough in the sky to burn off any dawn mist. At this time of the day, before people and animal activity kick dust and pollution up into the air, the atmosphere can have a clarity not found at any other time. Here, as if spotlighted, this black-bellied bustard stands transfixed in morning's first warmth, its back feathers transformed into a cape of golden embroidery.

PHOTOGRAPHER:
Roy Glen
CAMERA:
35mm
LENS:
500mm
FILM:
ISO 50
EXPOSURE:
½₅₀ second at f4
LIGHTING:
Daylight only

The bright, low sunlight of late afternoon has given us a real insight not only into the colouring of this immature grey wagtail but also an almost tangible sensation of the downy softness of the bird's feathers. When there is an obvious difference in exposure between the foreground subject and its surroundings, careful metering allows you to exploit the contrast to produce a strongly three-dimensional photograph.

PHOTOGRAPHER:
Roy Glen
CAMERA:
35mm
LENS:
400mm
FILM:
ISO 100
EXPOSURE:
1/125 second at f8
LIGHTING:
Daylight only

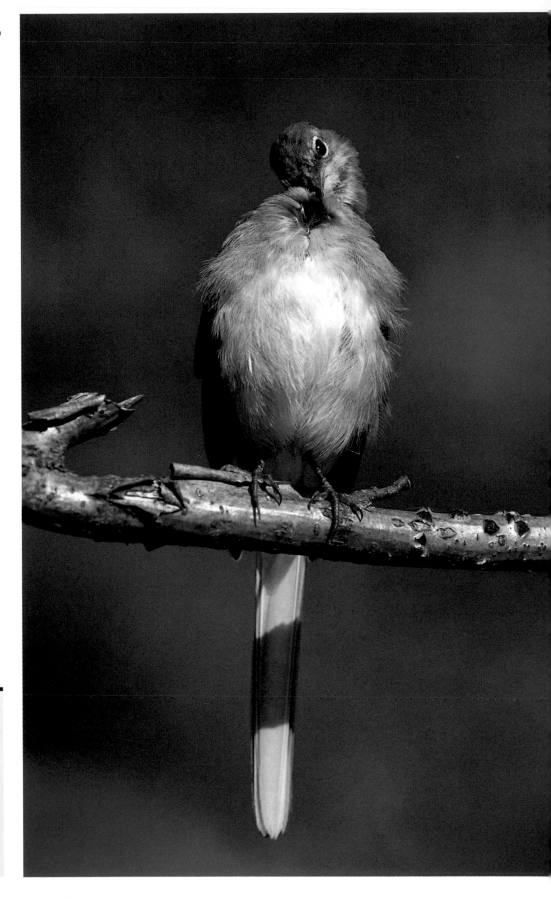

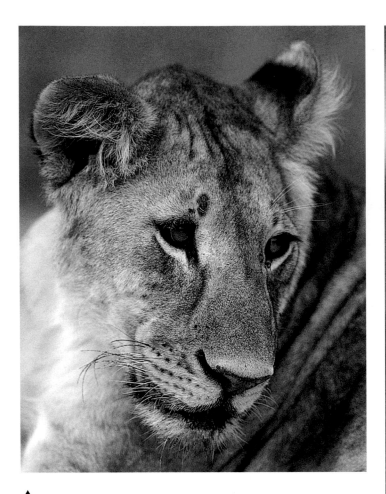

▲

A thin veil of cloud passed in front of the sun just as this photograph of a young lioness was being taken. The camera's automatic exposure system instantly compensated for the change in lighting intensity and the result is this softly lit portrait devoid of the harshness that may have existed had the sunshine been unobscured and at full strength.

PHOTOGRAPHER:
Roy Glen
CAMERA:
35mm
LENS:
400mm
FILM:
ISO 64
EXPOSURE:
1⁄125 second at f4
LIGHTING:
Daylight only

PHOTOGRAPHER:
Roy Glen
CAMERA:
35mm
LENS:
500mm

FILM:
ISO 100
EXPOSURE:
1⁄60 second at f5.6
LIGHTING:
Daylight only

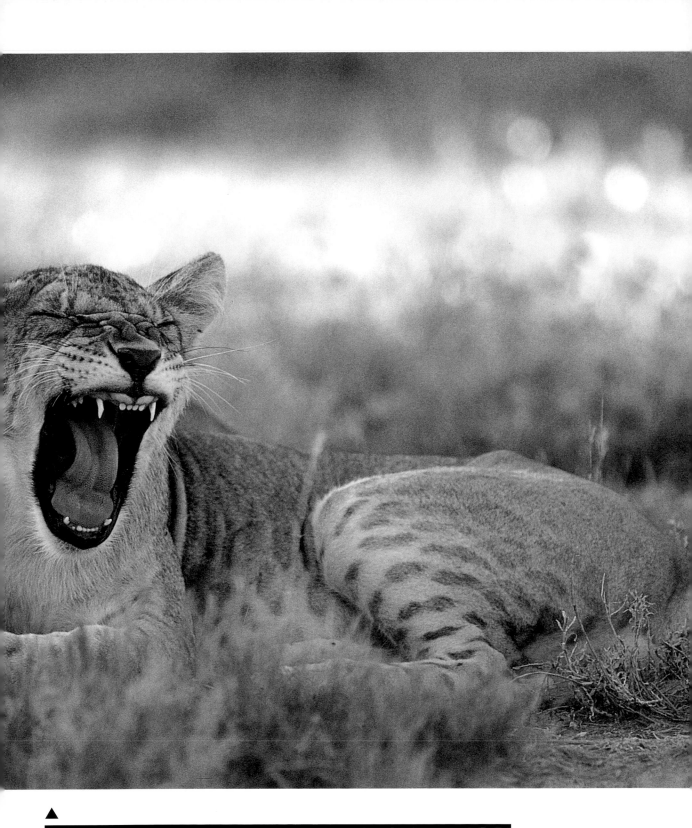

▲

This young adult lion has been lit entirely by light reflected off nearby rocks, as well as by skylight diffused through a canopy of nearby trees that are out of range of the angle of view of the lens. Contrast on the subject itself is low, since all the shadows have been filled and highlights have been muted, but the lighting quality imparts the perfect mood for the sleepy animal. A large part of a lion's day is spent resting, and if you are patient and keep your lens focused and ready, you should at some stage have the opportunity to snap a tooth-filled yawn.

Silhouette lighting

SILHOUETTES MOST OFTEN OCCUR by accident, when you fail to compensate exposure for the fact that the sun (or any other principal light source) is behind the subject and, thus, shining directly into the camera lens. In effect, the camera's light meter registers the bright light in front of it and closes the aperture down and/or reduces the shutter speed, failing to take into account the fact that the side of the subject facing the camera will be in deep shadow and require more exposure than the general scene.

However, there may be occasions when you want to create, quite intentionally, a silhouetted type of lighting effect. By creating a silhouette through underexposure, you strip away all subject surface information, such as texture, pattern and form. What remains is shape, which can be one of the most graphically powerful of all the subject attributes.

CREATING SILHOUETTES

- Find a camera position where the sun is behind the subject shining toward the camera lens.

- Take a light reading from the brightest area within the frame. If necessary, point the camera up at the sky, lock that light reading into the camera and then recompose the shot.

- If you want some subject surface information to record, open up one or two stops. Bracket exposures if you are in doubt about the final appearance of the subject.

- If the sun is shining too directly into the camera, use a lens hood or your hand (right) to shield the front of the lens. This will prevent, or at least minimize, flaring, which can destroy the effect you are trying to create.

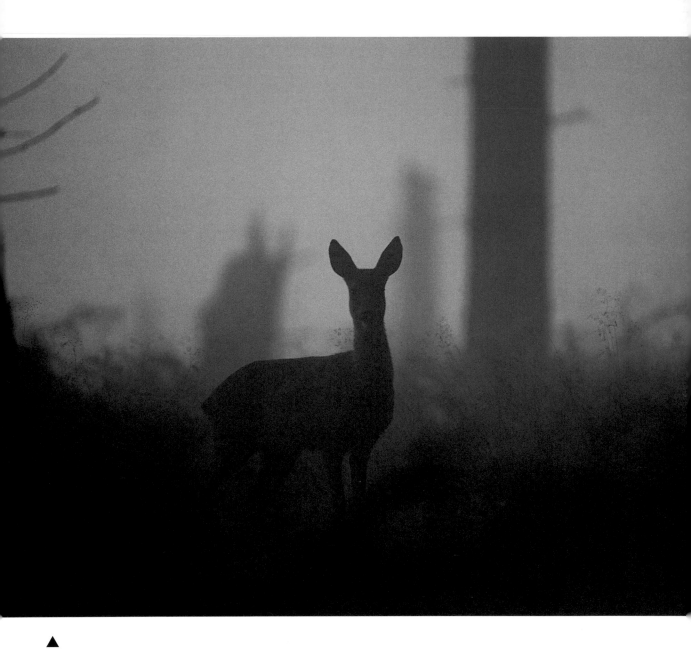

▲

Smoke from nearby fire outbreaks has formed an even-toned mist-like effect that has greatly simplified the background in this photograph of a deer. Light from a morning sun has been bounced around within the pall of smoke to produce a light reading that underexposes the main subject by about 2 to 3 f-stops. With much information removed from the scene by the smoke, shape becomes the dominant subject element.

PHOTOGRAPHER:
Bert Wiklund
CAMERA:
35mm
LENS:
210mm
FILM:
ISO 100
EXPOSURE:
¹⁄₆₀ second at f8
LIGHTING:
Daylight only

Looking more like a painting than a photograph, these greater flamingos, with their graceful, snaking necks and stick-like legs, proved to be perfect subjects for a silhouette-lighting technique. Taking a light reading from the brightest part of the scene, and making no allowance at all for the exposure needs of the birds, the photographer then adjusted the position of the horizon in the viewfinder so that the subjects would be seen largely against the liquid gold of the water.

PHOTOGRAPHER:
Roy Glen
CAMERA:
35mm
LENS:
400mm (with x1.4 converter)
FILM:
ISO 64
EXPOSURE:
⅟₆₀ second at f8
LIGHTING:
Daylight only

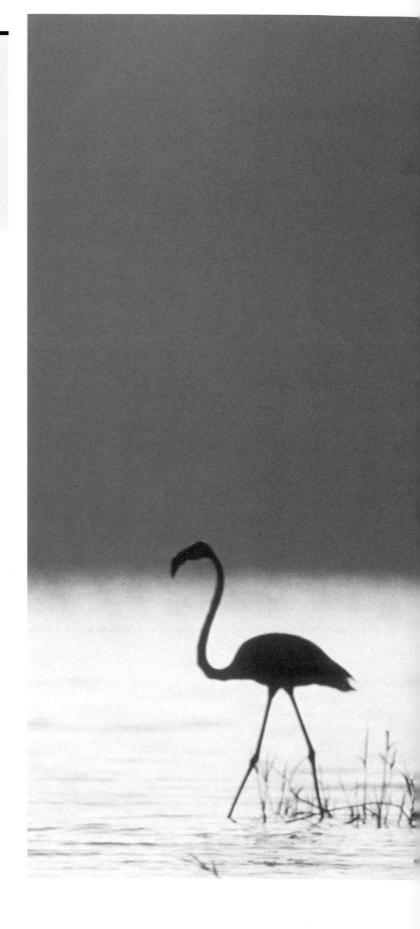

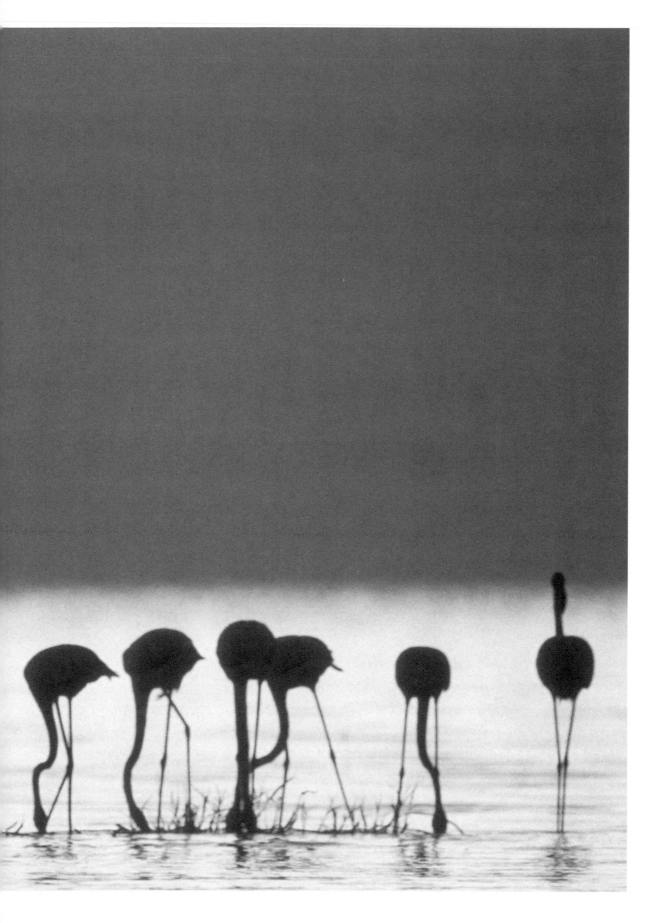

An effective way
to produce a
silhouette is to
find a camera
position that
shows your
subjects, here a
pair of magnificent
reindeer, framed
against the sky.
Even if the sun is
not within the area
encompassed by
the lens, skylight
is often sufficiently
bright to produce
the required
exposure difference
for the technique
to work. High on
a mountain escarp-
ment, the
background to
these reindeer is a
low bank of cloud,
which not only
helps to obscure
all extraneous
background detail
but also concen-
trates the viewer's
attention on the
shape of the
animals alone.

PHOTOGRAPHER:
Bert Wiklund
CAMERA:
35mm
LENS:
400mm
FILM:
ISO 100
EXPOSURE:
$\frac{1}{125}$ second at f11
LIGHTING:
Daylight only

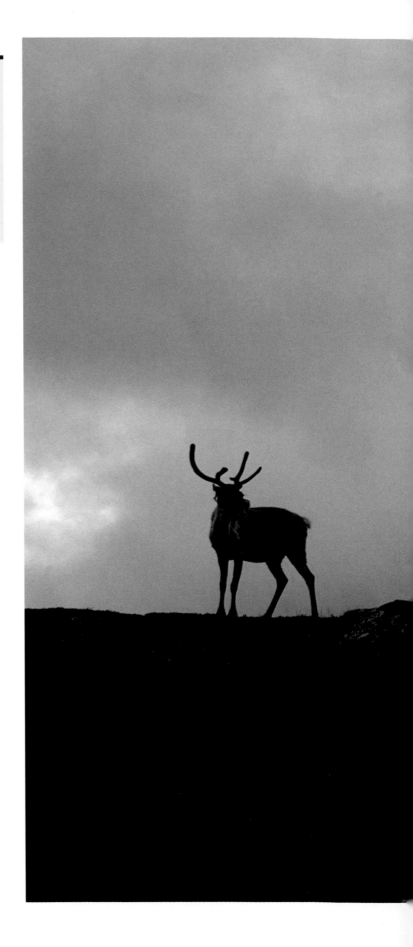

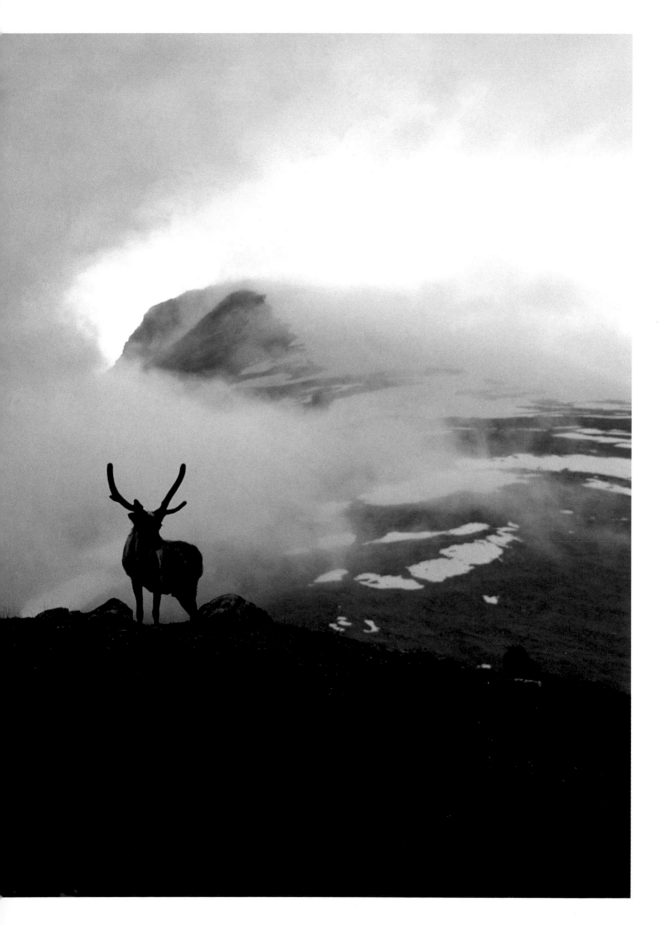

Using the frame

WHAT OFTEN DISTINGUISHES A SNAP from the type of picture that makes you stop and look closely is the way in which the photographer has used the entirety of the picture area to create a composition that reaches out and really grabs your attention. Try to think of the viewfinder much as an artist would approach a blank piece of canvas. Look for your main focal point, the pivot around which you can build the rest of the composition. Think of the different subject planes – the foreground, middle ground and background. Subject elements positioned within these planes will help to emphasize the three-dimensional nature of the picture. Also consider subject placement – centre framing tends to produce a solid, very formal type of effect, while off-centre framing produces a more active and vibrant composition. Naturally occurring lead-in lines within the scene will help to guide the viewer's attention to specific areas of the frame, while diagonal lines emphasize movement and activity, even with a static subject.

PHOTOGRAPHER:
Bert Wiklund
CAMERA:
35mm
LENS:
105mm
FILM:
ISO 100
EXPOSURE:
1/125 second at f22
LIGHTING:
Daylight only

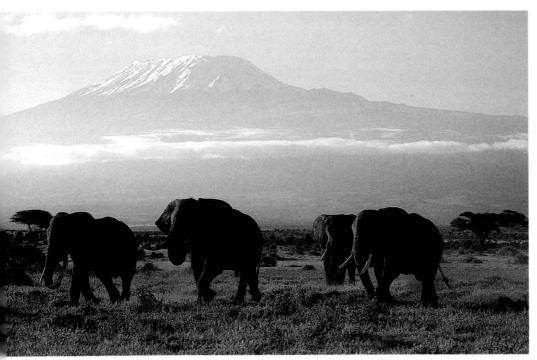

To achieve this picture, the photographer found the perfect camera position to show the magnificent Mount Kilimanjaro. Having established himself out of sight, he sat back and waited for something to come along to complete the composition. He knew from local guides that a family of elephants often used this route, and so he had a good idea of how the shot should look before the subjects arrived.

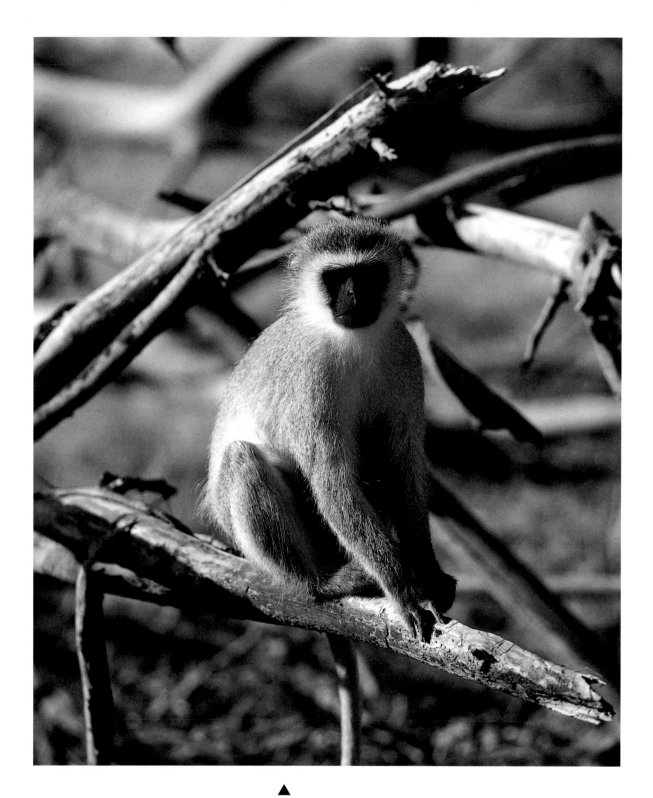

PHOTOGRAPHER:
Bert Wiklund
CAMERA:
6 x 7cm
LENS:
250mm
FILM:
ISO 50

EXPOSURE:
⅕₀₀ second at f4
LIGHTING:
Daylight only

▲

The central framing of this black-faced monkey has been cleverly balanced by the sense of movement and tension imparted by the diagonal lines of the fallen tree branches the subject is using as a perch. The wide lens aperture selected has reduced depth of field substantially, creating an enclosed space within which the monkey stands out strongly.

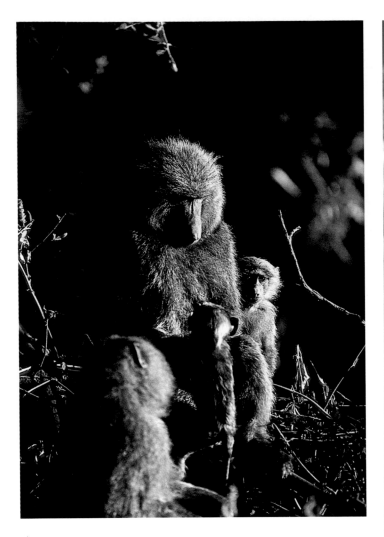

Here the photographer has used the very selective angle of view of a telephoto zoom lens to fill the frame with nothing but the subjects – a family of baboons. Because of your ability to crop out the surroundings when using a long lens, pictures such as this can be achieved out in the wild – in the animals' natural habitat – or in the confines of a zoo, as long as you ensure that you exclude all clues of their captivity, such as buildings, other people, wire or bars.

PHOTOGRAPHER:
Bert Wiklund
CAMERA:
35mm
LENS:
70–210mm zoom (set at 210mm)
FILM:
ISO 100
EXPOSURE:
½₅₀ second at f4
LIGHTING:
Daylight only

PHOTOGRAPHER:	EXPOSURE:
Bert Wiklund	**½₅₀ second at f16**
CAMERA:	LIGHTING:
6 x 7cm	**Daylight only**
LENS:	
50mm	
FILM:	
ISO 50	

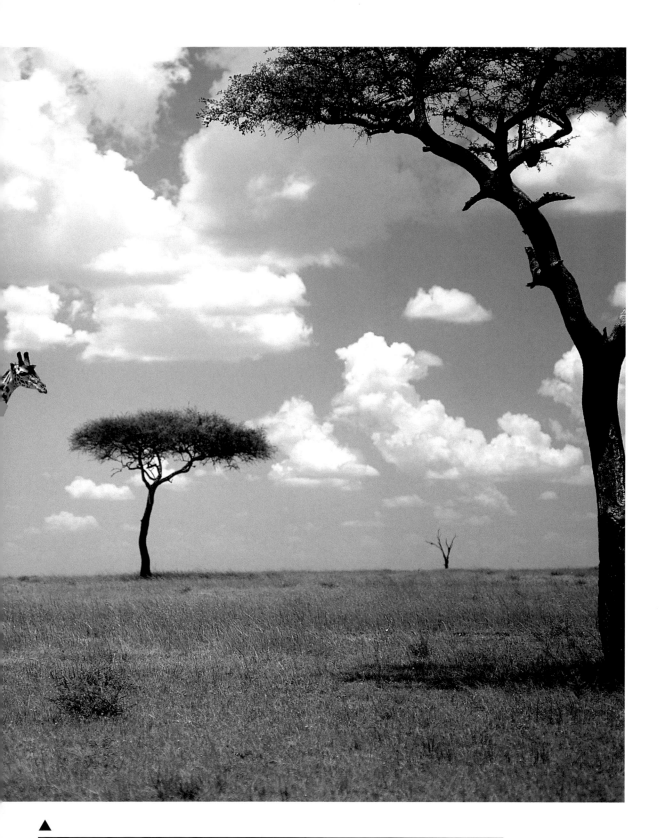

▲

You can see here just how well the photographer has defined the foreground, middle ground and background. The giraffe occupies an off-centre position in the middle ground, and has been balanced by the foreground tree on the extreme right of the frame. The background tree, whose shape echoes that of the near tree, is centre-frame and effectively anchors the entire composition. All of this has been complemented by the eye-catching arrangement of clouds.

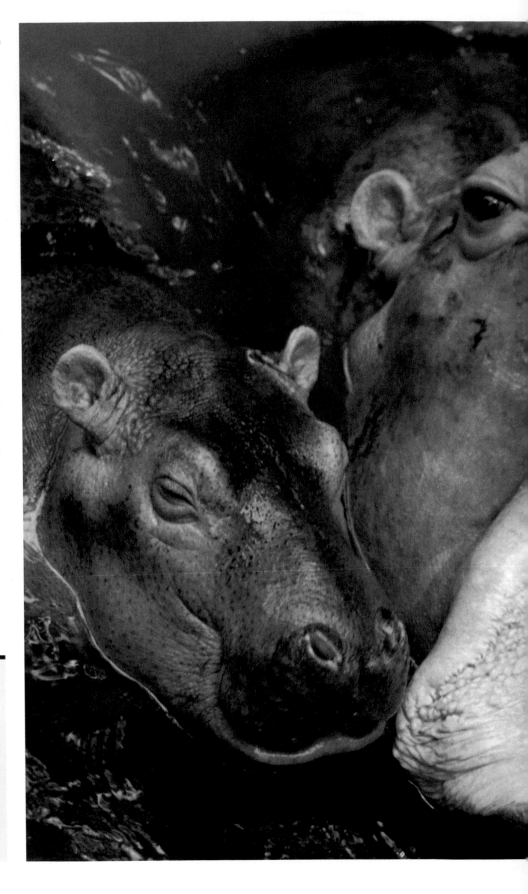

Although hippopotamuses may appear slow and lumbering they can, in fact, move remarkably quickly and are probably one of the most dangerous animals you could encounter in the wild. And they are especially dangerous when they have young to defend. It is not recommended that you ever get close enough to a nursing hippo to take this type of picture with a wide-angle lens, except when the animal is safely confined behind bars or is otherwise separated from the public.

PHOTOGRAPHER:
Ted Clark
CAMERA:
35mm
LENS:
28–70mm zoom (set at 35mm)
FILM:
ISO 100
EXPOSURE:
$\frac{1}{500}$ second at f4
LIGHTING:
Daylight only

Recording moving subjects

LIGHT LEVELS PERMITTING, you will often have the opportunity to use a variety of different shutter speeds for any particular shot. In addition to helping to control exposure, in combination with the lens aperture, the shutter speed also affects the way in which a moving subject is recorded on film. With fast modern emulsions and lenses with wide maximum apertures, you could, for example, select a shutter speed of ½₀₀₀ second or even ¼₀₀₀ second and stop virtually anything dead in its tracks. Alternatively, you could select a very slow shutter speed so that a moving subject records on the film as something more like an impressionistic blur.

A third way of recording a moving subject, however, is known as panning (see below). Using this technique, you move the camera to keep the subject in the viewfinder while the shutter is open. In this way, the subject should record relatively sharply while all static parts of the scene are elongate into streaks and blurs.

PANNING

- Select a shutter speed appropriate for the subject. For example, for a rapidly moving animal you need to select a shutter speed slow enough for the background to blur as you pan the camera but one that will still record the animal with sufficient clarity. There are no rules governing this, but bear in mind that shutter speeds of ½₂₅ second or faster may be too brief to allow the background to blur effectively.

- Line the moving animal up in the viewfinder before starting the exposure, then press the shutter release while moving the camera to keep the subject in the same part of the frame. Keep your legs firmly planted in the same position and swivel from the waist as you follow the animal's movements.

- As in a golf swing, follow through with the camera even after your hear the shutter close.

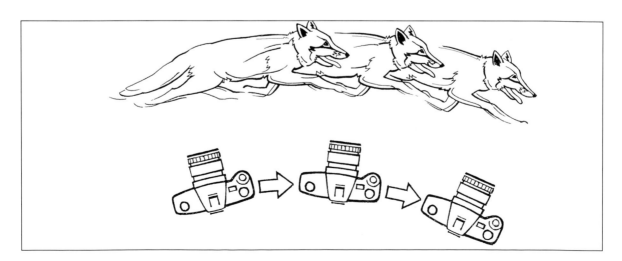

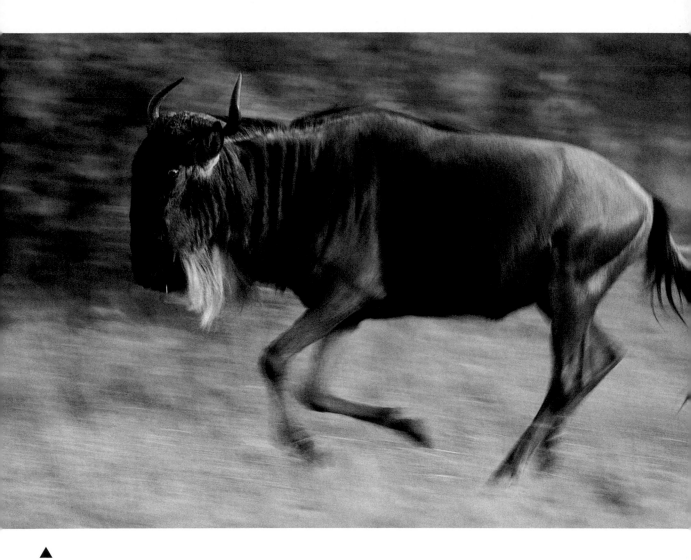

In order to take this picture of a running wildebeest the photographer selected a shutter speed of ⅟₃₀ second and then panned the camera to produce an evocative composition full of action and excitement. In the lighting conditions at the time and the equipment he had available, it would have been possible to select a shutter speed of ⅟₂₀₀₀ second to freeze completely all subject movement. However, as is often the case with photography, you need to make split-second decisions that will affect how the subject is interpreted.

PHOTOGRAPHER:
Bert Wiklund
CAMERA:
35mm
LENS:
250mm
FILM:
ISO 100
EXPOSURE:
⅟₃₀ second at f11
LIGHTING:
Daylight only

Compared with the previous image, in which the subject was panned using a slow shutter speed, here the photographer took an entirely different approach and used a very brief shutter speed to record two flamingos 'frozen' in flight. Sometimes you will not be able to select the precise shutter speed you need to use for a particular effect because you will not have an aperture available to compensate for exposure.

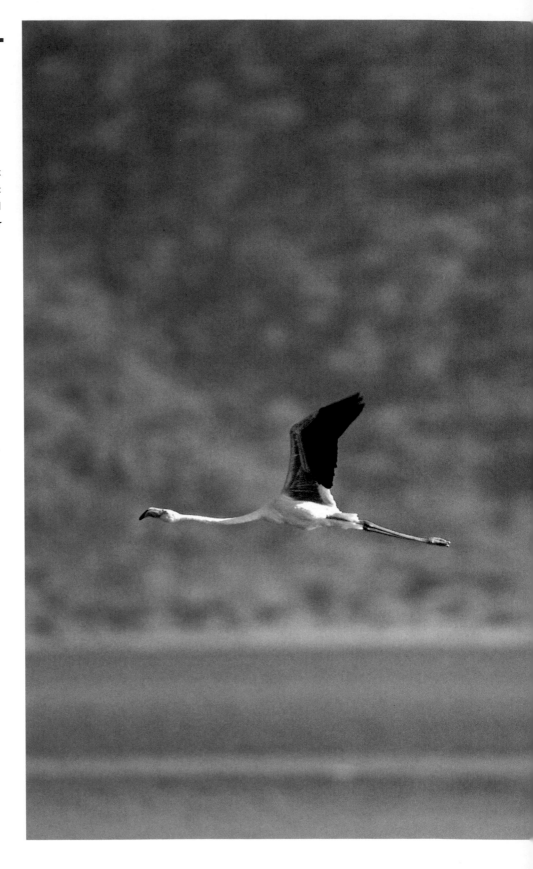

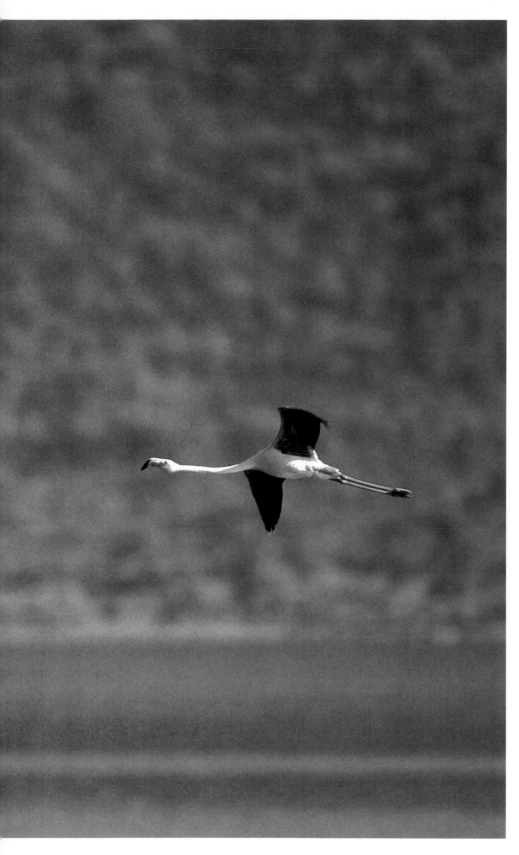

PHOTOGRAPHER:
Roy Glen
CAMERA:
35mm
LENS:
500mm
FILM:
ISO 100
EXPOSURE:
1/500 second at f4
LIGHTING:
Daylight only

5

PORTFOLIO

Max Gibbs of 'Goldfish Bowl'

Max Gibbs's photographic business – Goldfish Bowl – specializes in photographing the seemingly infinite variety of fabulous colours, markings, shapes and habitats found in the fish world. His work is mainly commissioned for publication in specialist fish-keeping books and magazines, but these days there is an increasing call on his expertize in producing images for use in advertising, posters and other types of publicity material.

Max's studio is equipped with a lighting system based on three studio flash lighting heads mounted on a purpose-built tracking system that allows a wide range of side-to-side, back-and-forth and up-and-down movements. Only one of the lights, however, is cabled up to his 6 x 4.5cm medium format camera – the other two have built-in slave units to ensure that they fire in synchronization with the first when the shutter is tripped. Max has found a tripod too restrictive for tracking his sometimes very active and elusive subjects, so instead he uses a stool on castors as a movable camera support. The stool also has a full range of height adjustments for extra shooting flexibility.

The black-outs blinds for the studio windows opposite his tank set-ups do not produce complete darkness in the studio – they hold back just enough light to

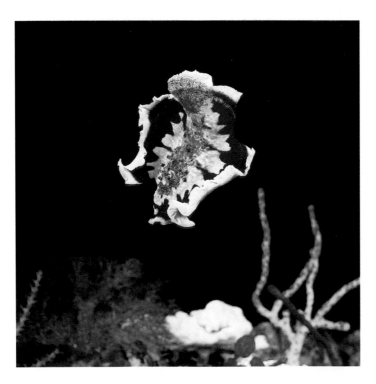

The Spanish dancer in swimming mode is not the easiest of creatures to focus on. The undulating mantle of the nudibranch moves rhythmically but quite quickly, changing the focus-target area constantly. Out of the 10 frames taken of this creature, only two were usable.

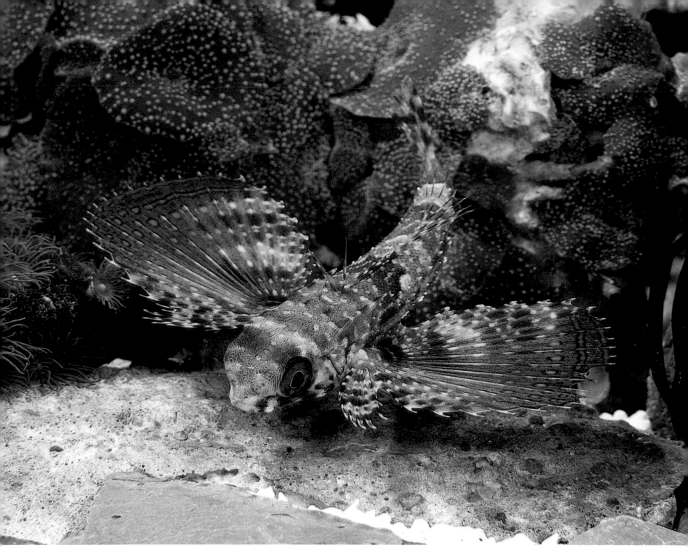

prevent unwanted reflections appearing in the glass-side tanks. Working with glass always throws up the problem of reflections and Max has developed a range of strategies to cope with them, including wearing black, long-sleeved shirts and black gloves to make himself more invisible. As well, Max has produced a range of different-sized black discs made out of cardboard. These discs have holes in them for the front of the lens to show through, and the expanse of black cardboard is usually sufficient to mask most camera, hand and face reflections.

The most obvious problem that springs to mind when using flashlight to illuminate subjects behind glass is that of 'hot-spots' – intense and very localized highlights that completely degrade subject quality wherever they appear. With the built-in modelling lights found on most studio lighting heads it is easy enough to see if the light is being reflected back toward the lens from the glass-fronted aquarium. If your lights don't have modelling lights, then you can set up small desk lights in the same positions and at the same angles and see what type of effects they create.

However, common sense plays a large part in the process of setting the lights for any particular subject. If, when you look through the viewfinder, you can see the flash units reflected in the glass of the tanks, then you can guarantee that they will also appear in the final processed photographs.

▲

The principal feature of the gurnard is its beautifully marked pectoral fin. But to record this you need to react quickly since the display is only very brief. Creating a well-composed image is also difficult, since this species tends to keep flat to the bottom.

METERING AND DEPTH OF FIELD

'Metering is something I have never used, relying on my own judgement to determine the lens aperture. With so much variation in the reflective quality of the fish subjects this, in my view, is the only reasonable approach. Silver and bright fish, for example, need to have the lighting angled and distanced accurately to prevent them burning out at even the smallest aperture. Conversely, black, brown, or dark-blue fish need more direct, less-distant, lighting and probably larger apertures too. Developing an eye for exposure is the best option, and you will be surprised how quickly you develop this instinct with experience. The smallest possible aperture is obviously essential to maximize the available depth of field when you are working with tiny subjects, especially when they have a form that is not laterally compressed and may have protruding bits that will appear obtrusively out of focus forward of the main subject area.'

▶

The puffer fish inflated in this manner makes a popular image, and it is not difficult to provoke this response. It does mean, however, that the fish suffers stress, even more than placing it in the photographic tank. You need to be aware that such induced swelling under stressful conditions can lead to permanent damage to the creature. This fish was unusual, however, in that it inflated itself without being handled or molested in any way, and did so with control and thus suffered no damage.

◀

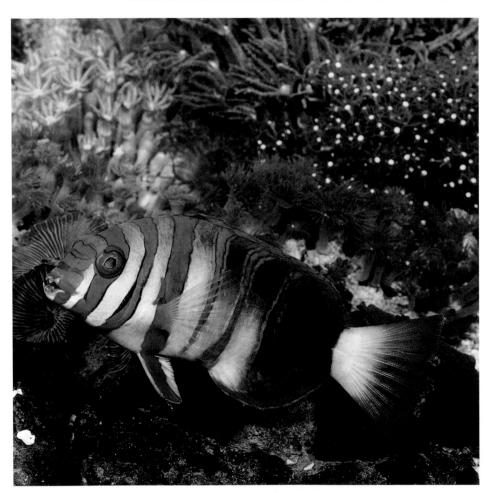

This harliquin tusk fish makes a superb study with its fantasy colouring and blue 'tusks'.

WATER QUALITY AND CLEANLINESS

'The aquarium must, of course, be scrupulously clean. I have seen instances of otherwise excellent pictures spoiled by water-runs that have dried on the outside of the front glass, or algae growth on the inside. Scratches in the glass of the tank, which are hardly discernible with the naked eye, become glaring blemishes when seen in close-up shots. Water quality can also have a dramatic effect on colours. Floating bits are obviously to be avoided, but all too often the aged water in some aquariums has a greenish or yellowish quality, as opposed to the sparkling, colourless quality of freshly drawn water. The difference between images obtained in the varying water qualities can be marked. Adjacent coloured surfaces of walls and other elements will also often reflect unwanted colour casts into the aquarium. However, this can also be turned to your advantage. By using a coloured base substrate in the aquarium it is possible to enhance the subject, with the reflected colour cast suffusing its underparts (which are often quite light in colour). Bear in mind, however, that this type of technique produces an artificial quality in the image and must be used judiciously, if at all.'

▶

This juvenile trigger fish has the combination of golden base colour overlaid with electric blue. It is easy to record one or other of these colours accurately, but usually one colour is achieved correctly at the expense of the other. In this example, both colours, and their reflective qualities, have been well represented in the image.

◀

This boxing crab is very tiny – less than ½in (1cm) across its carapace. The even smaller anemones attached to it are thought to be for protection and also for food gathering. To take this shot, a bellows unit was attached to the camera with the addition of two +3-dioptre and one +2-dioptre lenses to increase the magnification still further.

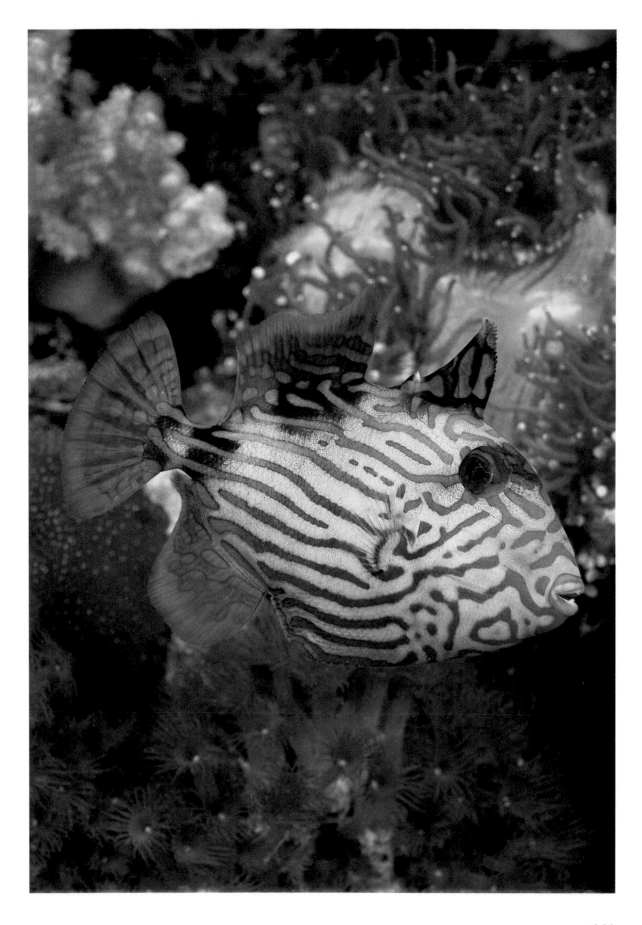

▼

The South American leaf fish is one of the best examples of mimicry in freshwater fish (there are numerous examples in marine species). The leaf you can see in this picture was sandwiched between two sheets of glass and the fish was eventually persuaded to move down past it to complete the composition.

LIGHTING ANGLE AND BACKGROUND

'As a general guide, the front lighting unit needs to be far enough back and angled at about 45° to eliminate reflections, but variations on this arrangement are often necessary in order to obtain the best results. Toplighting, used to pick out the top edge of the subject or to light the background, also needs to be carefully positioned for best results. In my set-ups, I only ever alter the power settings of this toplight – the front lights are always used at full power but at varying distances from the tank to produce different intensities.

 Plain backgrounds can give dramatic results, but less flamboyantly coloured subjects will often benefit from being seen against a coloured or "dressed" back-ground. The impact of fussy subjects can be diluted by a cluttered background. When considering backgrounds, don't become lazy – it rarely works for one fish after another to be "plonked" into the same tank setting. Each subject needs to be considered individually if you want the highest-quality photographs.'

▶

The positioning of these three powder blue tang, all in formation and each crisp and sharply focused, was achieved only after a huge amount of effort and patience. Their movement in the tank was restricted somewhat using an angled sheet of glass, but success was largely down to the waterflow technique (see page 144).

Exposure is tricky
with the boxfish.
You need to
achieve a good
balance between
the contrasting
dark-blue flanks of
the fish and its
white, spotted
upper body and
yellow head.

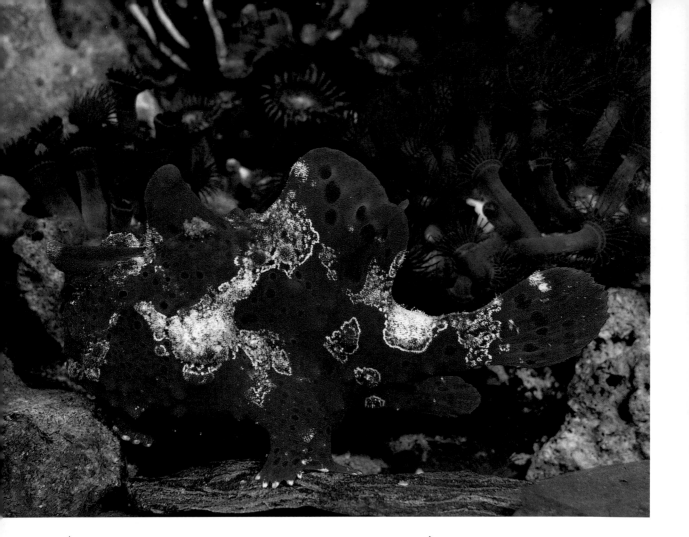

This unusually coloured frogfish shows the markings of mimicry that completely mask it when it is in the shelter of a surrounding sponge. But exposed like this in open water it reveals the intricacy of its markings and the white 'toenail' extensions to its modified pectoral fins.

The bannerfish is one of the species of butterfly fish, and it is undoubtedly seen at its best in profile, where the overall shape and contrasting markings can be fully appreciated. Lacking any vibrant colours of its own, a colourful background was decided on to complete the picture.

The dwarf gourami
is one of the most
attractive of all the
freshwater fish,
particularly, as in
this example, when
it is in full breed-
ing fettle. The
lighting needs
to be discerningly
positioned in
order to capture
accurately the true
colours and all the
subtle highlights,
and there is the
danger of burning
out the lighter
parts of the fish if
the lighting is too
direct and intense.
A glass separator,
positioned to
restrict its
movements, and
an unseen female
gourami, were
instrumental in
creating this shot.

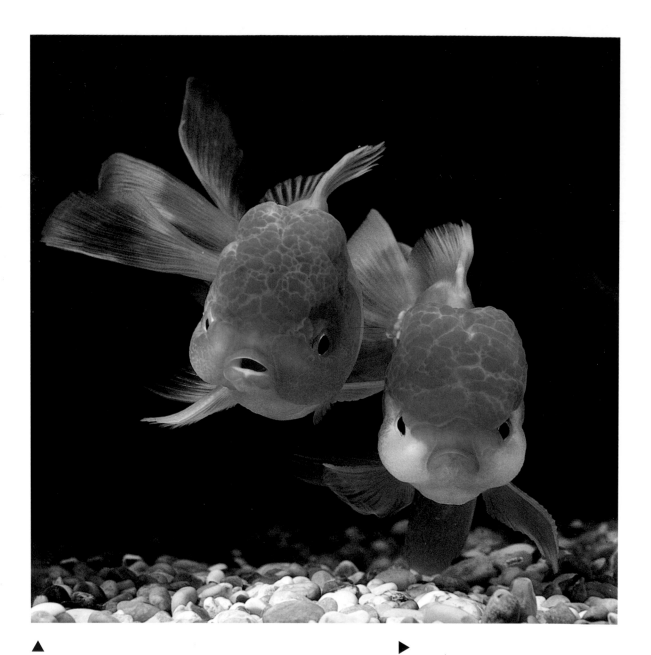

The concept of this shot of a pair of red oranda was specifically requested by the editor of a fishkeeping magazine. Although it looks like a simple image, it took well in excess of an hour just to get the fish in the right position. This one shot is the only perfect one from more than five taken at the session. Everything about it is right – all four eyes are showing; one has its mouth open while the other one has it shut; the fins are perky; and the picture has a fresh, cheeky appearance. The black background was specified by the client as the shot was to be used for a front cover.

Seahorses invariably attract attention, even if the audience is not composed of dedicated fishkeepers. These particular species are shown in association with different-coloured sponges and you can see that the seahorses are beginning to alter their body colour to match. Water-flow has played an important part in this image in encouraging the fish all to face in the same direction and not to turn their heads away from the lighting units and camera. They refused to be positioned and manipulated, and so composition is largely a matter of luck.

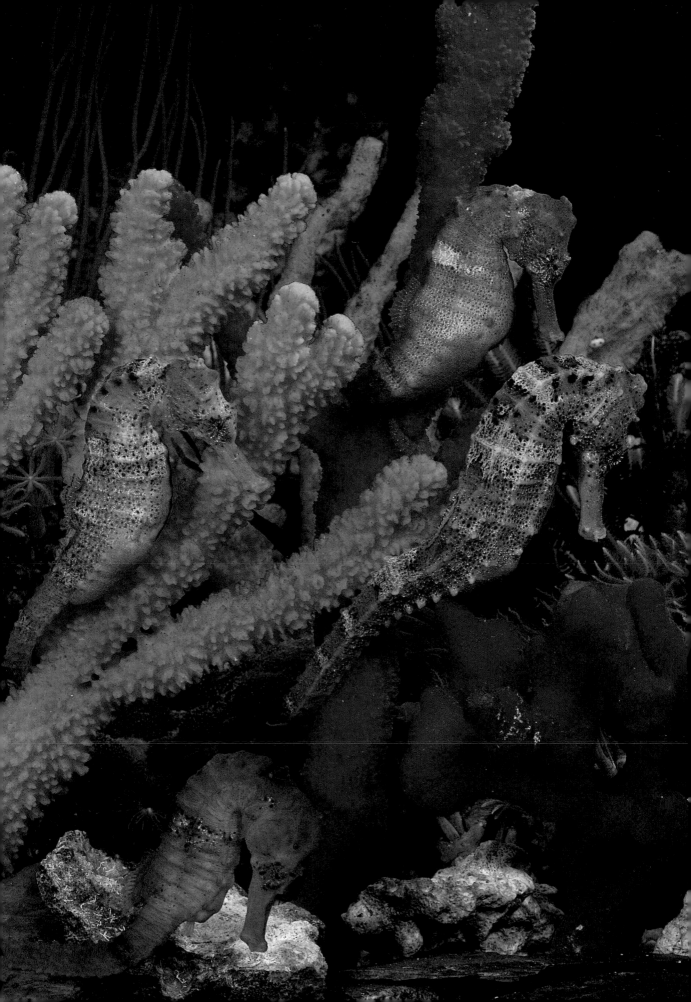

The mandarin fish is a shy animal in nature and will rarely display with spread fins in the confines of a photographic tank with modelling lights blazing. The modelling lights on two of the heads were quenched, leaving only one on to ensure sharp focus. A rival male mandarin fish was accommodated in an adjacent see-through section of the tank to stimulate this display reaction.

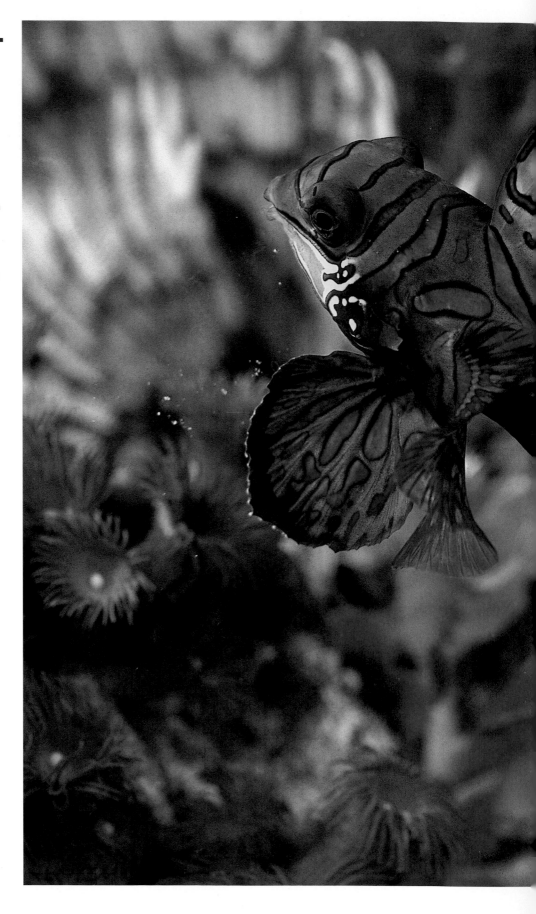

Directory of photographers

Ted Clark

95 Yeovil Road
Sandhurst
Berkshire GU47 0QH
UK
Telephone: + 44 (1276) 31803

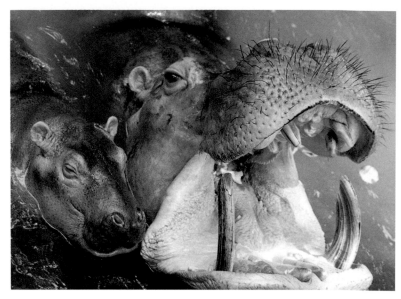

Ted Clark's interest in photography was first fired in 1957 when he purchased a home made photographic enlarger from a jumble sale constructed from an old 'Cow & Gate' dried milk tin. This unlikely start prompted Ted to purchase his first camera – a Boots Bencini – progressing later to a Kodak Retinette. His first single lens reflex camera was a Zeiss Contaflex. Using this SLR, Ted began submitting work and, after much perseverance, he landed regular freelance work with a local newspaper, the *Barnes & Mortlake Herald*, in his spare time while working full-time or a photographic retailers in Richmond, Surrey.

Ted's particular interest in photographing people and candid work led him to work for a private detective agency – 'a very interesting aspect of my career' – and later he was to spend many years covering weddings and portrait photography for a studio in Hampton Court. This phase of

Ted's career put him on more of a sound financial foundation and allowed him to purchase a Hasselblad. Over the years he has tried and used many different cameras, finally settling for a Pentax, which he finds small and reliable, and with excellent optics. His current preference in the medium format range is a Bronica ETRS, and his most generally useful lenses are a 20mm wide-angle and medium-range zoom for animal subjects, which have always been a field of photography Ted enjoys. Ted's preference for film stock is Fujichrome for slide work and Fujicolor for prints.

Photograph on pages: 128–129.

Paddy Cutts

'Animals Unlimited'
25 Hollies Road
Ealing
London W5 4UU
UK
Telephone: + 44 (181) 5684960
Fax: + 44 (181) 5609965

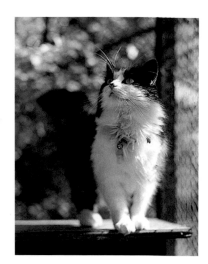

Paddy's Cutts first career was not, in fact, photography. After studying archaeology she went on to train and work as an air stewardess. It was her passion for cat breeding, however, that was to change the course of her life. Starting some 25 years ago, her success in this field led her into the highly competitive world of cat showing. Trying without any luck to find a suitable photographer to record her animals, she finally undertook the task of teaching herself both the technical and aesthetic sides of photography. In 1978, Paddy set herself up as a professional freelance photographer and, stemming from this move, she founded her own photographic library – 'Animals Unlimited' – in 1980. By this time, Paddy had expanded her photographic interests to include dogs and other types of domestic animal, as well as cats. Paddy's love for and insight into the nature of her subjects is evident in all her work. As a child, she grew up with dogs, first a chow chow and then a greyhound, and it could

well have been this early experience that helped to mould her later career decisions.

In all, Paddy has written 16 books – four of them photographic works – and nearly all of them about animals. More recently, she has been working with cat food manufacturers, shaping the visual elements of their advertising campaigns and packaging. Among Paddy's most recent commissions was one for the department and food store Marks & Spencer working on the photography for their range of cat food products.

Photographs on pages: 1, 2–3, 7 8, 21, 22, 23, 24, 25,26, 27, 28, 29, 30, 31, 32, 36, 37, 38, 39, 41, 42, 43, 45, 46, 47, 48, 49, 50 51, 52, 53, 54–55, 56, 57, 58, 59, 84–85.

Max Gibbs

118-122 Magdalen Road
Oxford OX4 1RQ
UK
Telephone: + 44 (1865) 241825
Fax: + 44 (1865) 794511
E-Mail:
Photomax@compuserve.com

Max Gibbs started 'The Goldfish Bowl', an aquarium hobby retail operation, more than 40 years ago. The current aquarium centre is one of the largest in Europe and it handles a wide variety of fish and invertebrate species from around the world. Max's partner, Barry Allday, puts great emphasis on caring for the many thousands of fish that are

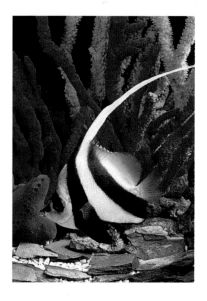

in stock at any particular time, ensuring a ready supply of fine specimens for loan to the photographic studio located in the same building. This combination of a specialist photographer and his chosen subject material at such close quarters has proved to be an invaluable facility, allowing new or prime specimens to be added to Max's photographic library – Photomax – as and when they become available. This facility is also most useful when commissioned work is undertaken.

The Photomax aquarium picture library was started by Max Gibbs as a semi-retirement project. A demand for high-quality aquarium subject pictures by specialist hobby magazines and books was soon recognized and requests for photographs began to arrive from a variety of sources. Semi-retirement was put off!

Photomax currently supplies pictures on a regular basis to

four hobby magazines, frequently supplying important front-cover images for these clients. However, the increasing use of photographs for the Photomax collection by book publishers, advertising agencies and packaging design companies, as well as producers of posters, fliers, brochures, point-of-sale material and all manner of other applications has created a lively demand.

The broad categories of images that Photomax specializes in include: tropical and temperate fish species (marine, freshwater and brackish); invertebrates (mainly tropical marine with some freshwater species, both tropical and temperate); aquarium plants and water lilies; and diseases and parasites associated with aquarium and pond fish. These categories are largely composed of medium format transparencies (6 x 4.5cm), shot in studio conditions on either Fujichrome Velvia or Provia. However, new images are constantly being added to the library and present stocks stand at about 15,000 images. An additional 3,500 images are with the prestigious Oxford Scientific Films Stills library. Max is currently undertaking a new venture, adding underwater tropical marine material on 35mm film stock.

Photographs on pages: 10, 136, 137, 138, 139, 140, 141, 142, 143, 146–147, 148, 149, 150–151, 152, 153, 154–155.

Roy Glen

257 Eagle Park
Marton-in-Cleveland
Middlesbrough TS8 9QT
UK
Telephone & fax:
+ 44 (1642) 310644
Mobile: + 44 (973) 316745

Like many wildlife photographers Roy Glen's interest in taking pictures stemmed from a fascination with the natural world. Basically, Roy learned by trial and error, supplementing this practical, hands-on experience with reading lots of specialist books and magazines

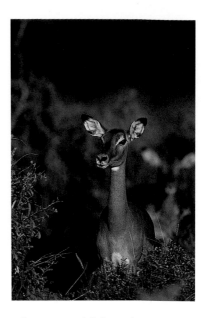

relating to wildlife and animal and photography. Most of these, he finds, give sound advice and are undoubtedly a source of motivation.

Roy currently takes photographs on a semi-professional bases while working as a partner in his family business retailing computer supplies. This work commitment means that his photography is often restricted to areas close to his home, leaving very early in the morning before starting work, or travelling further afield on weekends and vacations.

Roy's collection of wildlife pictures has been built up over the last four years and this body of work consists mainly of birds and some mammals. He submits pictures to the magazine market and other publishers and some of his material is handled by a specialist wildlife photographic agency.

A love of taking wildlife pictures has taken Roy to both Africa and the USA. On these

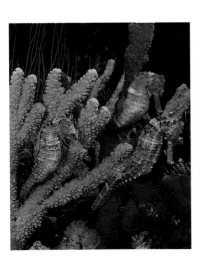

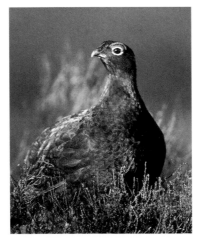

trips he avoids travelling in groups: '. . . to obtain decent images I like to work at my own pace, staying with a subject for long periods – impossible to do if you are with a group taking holiday snaps.' Nearer to home, he usually concentrates on one subject at a time, having a specific picture in mind as well as a method for getting that result seems to work best for him.

Photographs on pages: 9, 62–63, 70–71, 72, 73, 75, 76, 78, 80, 81, 82, 83, 105, 106–107, 108, 109, 111, 112, 113, 114, 115, 116–117, 120–121, 132–133.

Bert Wiklund
PO Box 142
DK-7330 Brande
Denmark
Telephone: + 45 97 18 23 35
Fax: + 45 97 18 39 13

Bert Wiklund was born in Sweden 45 years ago, but he has been working as a professional photographer in Denmark for the last 20 years. Bert's academic background is in economics and social science and he has no formal training as a photographer – he says: 'You can't get a formal degree in photographing nature anywhere in the world yet.' With his vast experience in, and love of, nature photography, his current client list is mainly composed of specialist magazines and books, but his interests also extend to the world of advertising

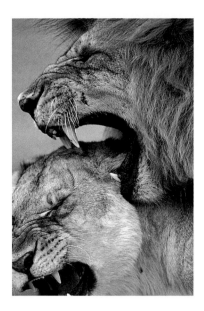

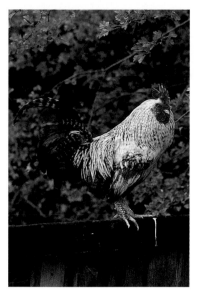

photography. 'Everybody likes to have a green image today,' Bert wryly remarks.

Bert finds nature photography the most wide ranging of the photographic disciplines, extending, in his own words, 'from bacteria to galaxies'. To cope with this spread of subject matter, Bert finds himself using a range of different camera formats: a 35mm Nikon, a medium format Pentax, and even a half-plate camera when detail and quality are paramount. For more specialized imagery, his arsenal also contains panoramic and underwater cameras.

'Pictures of nature and of animals are difficult to predict and plan for in advance. You have to grab each opportunity as it arises.' Today, this policy has created for Bert a photo archive of more than 150,000 pictures from every continent on the planet. And to make picture selection as easy as possible for

clients, a 10,000-picture computer-readable compact disc can be sent out to give a flavour of the types of subject matter available.

Photographs on pages: 65, 66–67, 68, 69, 77, 79, 91, 92–93, 94, 95, 96, 97, 98–99, 100, 101, 106, 119, 122–123, 124, 125, 126–127, 131.

Acknowledgements

In large part, the production of this book was made possible only by the generosity of many of the photographers featured, who permitted their work to be published free of charge, and the publishers would like to acknowledge their most valued contribution.

The publishers would also like to thank the following organizations and individuals for their support and technical assistance and services, in particular Brian Morris and Barbara Mercer at RotoVision SA, Anne-Marie Ehrlich of E. T. Archive, and the equipment manufacturers whose equipment appears in this book.

All of the illustrations in this book were drawn by Brian Manning.

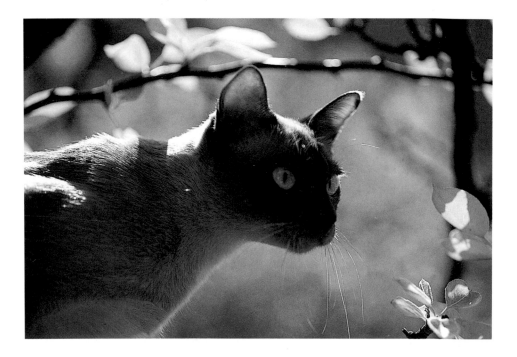